Two-Minute Monologs

Original audition scenes for professional actors

GLENN ALTERMAN

PALM BEACH COUNTY
LIBRARY SYSTEM
3650 SUMMIT BLVD
WEST PALM BEACH, FLORIDA 33406

MERIWETHER PUBLISHING LTD.
Colorado Springs, Colorado

Meriwether Publishing Ltd., Publisher
PO Box 7710
Colorado Springs, CO 80933-7710

Editor: Theodore O. Zapel
Cover design: Janice Melvin
Back cover photo: Billy Strong

Library of Congress Cataloging-in-Publication Data

Alterman, Glenn 1946-
 Two-minute monologs : original audition scenes for professional actors / Glenn Alterman -- 1st ed.
 p. cm.
 ISBN 13: 978-1-56608-038-5 (paper)
 ISBN 10: 1-56608-038-X (paper)
 1. Monologues. 2. Acting--Auditions. I. Title.
 PN2080.A447 1998
 812'.54--dc21
 98-3956
 CIP

3 4 5 06 07 08

This book is dedicated to the
Lab Theater Company
Michael Warren Powell (artistic director)
Randall Etheredge (managing director)
and
The Cherry Lane Theater Participating Artists
Susann Brinkley (producing director)

Contents

Acknowledgments

The author wishes to thank the following:

The Forty-Second Street Workshop (Michelle Bouchard, artistic director), Spider Duncan Christopher, Helen Hanft, Lanford Wilson, Jo Twiss, Kit Flannigan, Giselle Liberatore, Herbert Rubens, Anita Keal, Lucy McMichael, Robert Alexander, and all the other directors, actors and playwrights who have offered their invaluable assistance, comments and suggestions during the workshops and readings of these monologs.

Introduction

Finding the right monolog can be murder, believe me, I know. I know because the reason I started writing monologs in the first place came out of my frustration of trying to find one for myself. Like many other actors, I spent hundreds of hours searching through plays, monolog books, even novels trying to find just the right monolog. But it seemed like each potential monolog came with its own baggage. The really good ones had been done to death. Others needed major editing. Others worked only if you knew the play they came from. Others, well, the problems went on.

It seemed like it should be so simple. All I wanted was a well-written monolog with a compelling story that had a beginning, middle and end, some emotional journey I could identify with, and words that I enjoyed speaking. Considering that most auditions are two minutes and under, this seemed like a lot to ask for. So eventually, out of desperation, I started writing my own monologs. I tried to include all the elements that I felt were missing in most other monologs. At first it was hit and miss. But over time I started finding my way and began writing what I considered to be "top notch" monologs. I relied heavily (and still do) on other actors, directors and acting teachers for their feedback. When a monolog received a "rave" from everyone, it was generally one that I held on to. Actors seemed to enjoy doing them and that was very important to me. I mean it's one thing to read a good monolog in a book, it's another to see if it works and is effective as an

audition piece.

That initial crop of monologs led to my first published book of monologs, *Street Talk, Character Monologues for Actors*. The monologs were very popular, making that book the number-one book of original monologs in the country that year (1992). My subsequent monolog books, *Uptown* and *Two Minutes and Under* were also the number-one books of original monologs in the country in their respective years.

It's been several years since I've written a monolog or book of monologs. During that time I've written plays, screenplays and other theatre related books. Coming back to writing monologs has been a very exciting and satisfying experience for me. The response by actors and directors to these monologs has been very, very enthusiastic. But the final judge is you, the actor, reading this introduction, considering buying this book. It is your opinion that counts most. All I ask is that you leaf through the book and see if one of these characters calls out to you. If they do, please don't be afraid to say hello and get better acquainted.

Finally, I'd like to thank Meriwether Publishing Ltd. for having the confidence in me and giving me the opportunity to create what I believe is my best book of original monologs.

Glenn Alterman

Monologs
for Men

John W.

John W., a lonely man, slowly talks about his warm relationship with his pet cat.

1 Sittin' here by the window with my old cat,
2 Carl; looking out at the snow fallin', drinkin' my
3 coffee, tryin' to decide what to do today. Should
4 I go out, should I stay in? Carl doesn't seem to
5 have too much of an opinion on it though. So I
6 just talk to him about the snow. Tell him how
7 cold it is out there today, how lucky he is to be
8 inside here where it's warm. Carl just purrs and
9 listens and looks out at the snow through half
10 opened eyes. He's a damn good listener, Carl.
11 Should give a course in it to some of the people
12 in this town here, I'll tell ya. Purrs so loud you'd
13 think I was talking to him about a warm day in
14 Florida rather than the mess we got here in
15 Maine today. He appreciates, Carl, he does.
16 Remembers that rainy night when I found him
17 downtown all cut up, bleeding and thin and took
18 him home here and nursed him, stood vigil, and
19 saved all his nine lives in that one night. Carl
20 remembers, I'm sure. I'm sure he does. He'll put
21 his paw across my sockless foot and lean his
22 head there, looking up at me as I talk about
23 whatever, forever, doesn't matter. He's got no
24 opinions on any of it. Then pretty soon his eyes
25 start to close letting me know that he's about to
26 fall asleep and dream.... Oh I don't know, what-
27 ever the hell cats dream about. Then one last
28 wink letting me know that my words and voice

7

1 are a happy place for him. *(Smiling)* **He's my best**
2 **friend. Then he's asleep, as I continue petting**
3 **him, looking out on the town from my window**
4 **seat. Watching the snow fall, drinking my coffee,**
5 **trying to decide what the hell I'm going to do**
6 **today.**
7
8
9
10
11
12
13
14
15
16
17
18
19
20
21
22
23
24
25
26
27
28
29
30
31
32
33
34
35
36

Rob

*Rob recalls a frightening incident
from his childhood.*

1 He yelled, "Floaters?! What the hell are
2 floaters?! I got icebergs in my eye!"
3 I'd never seen my father so upset. I was just
4 a little boy then, maybe 6 years old.
5 "Help me doctor, get them out!"
6 The eye doctor was trying to tell him that it
7 was "nothing to be concerned about, just float-
8 ing spots in the eye that come with age."
9 "I got a business to run, got a family! I can't
10 afford to go blind!"
11 "You're not going blind, sir."
12 "Look, you don't see what I see! These little
13 black...."
14 "Floaters, sir, they're called floaters."
15 "I don't care what'cha call 'em! I'm going
16 blind, I tell ya!"
17 "It's nothing to be alarmed about. It's tempo-
18 rary."
19 But my father wouldn't listen. Kept ranting
20 about going blind, dying, brain tumors. The doc-
21 tor tried to calm him, but he wouldn't listen. I'd
22 never seen my father like this. Something must
23 be terribly wrong! Why wouldn't the doctor help
24 him?!
25 "C'mon!" my father said, yanking my hand.
26 We rushed out of the office. He found a phone,
27 called another doctor, then we jumped into a
28 cab. It was getting dark out. I looked up at him,

1 realized he was terrified. He was sweating, curs-
2 ing to himself. Something must be really wrong,
3 he's never scared. He could scare off bogey men,
4 thunderstorms. Suddenly, the back seat of the
5 cab disappeared. Then the doors flew off. Streets
6 were whizzing by. I know that block, I've been
7 there. There's Angelina's house. There's the play-
8 ground. The cab started spinning upward, high-
9 er. Something awful was happening! The lights
10 outside were all blurring together. I realized I
11 was alone, dad was gone. There was just the dri-
12 ver in the front seat, and he had no skin on his
13 face, looked like a skeleton. Where was he tak-
14 ing me? Where were we going? Higher and high-
15 er into the night sky. Spinning, spinning, up, up!
16 Darker, darker!
17 ...Then ...then — Ooooooh. Suddenly it felt so
18 good. Aaaaaah...Warm...Wet. Good. Yes.
19 *(A beat, then, a whisper)* "What did you do?"
20 Daddy was looking down at me. We were still
21 in the cab.
22 "What did I do?"
23 *(Whispering)* "Did you pee in your pants?"
24 I looked down, my pants were all wet. I
25 looked up at him, slowly nodded "yes." I was
26 going to get it now, I knew it.
27 But he smiled, said, "S'okay, don't say any-
28 thing." He put his hand around my head. I
29 leaned into him, slowly started to doze off.
30 When we got to the next doctor, after he
31 examined my father's eye, he said that word
32 again, "Floaters."
33 But my father smiled this time, said "So it's
34 nothing to worry about, no big deal?"
35 "Temporary," the doctor said, "It'll go 'way.
36 Comes with age."

1 My father looked down at me, smiled, said,
2 "Floaters."
3 "Floaters," I smiled back, not quite knowing
4 what it meant.
5 "C'mon, let's go home. Gotta change those
6 pants 'fore your mother gets back."
7 That night, after dinner, we sat on the couch,
8 watched T.V., just like always. I fell asleep in his
9 arms. I felt him lift me up, take me to my bed,
10 tuck me in.
11 "Good night dad."
12 "Good night son."
13 A kiss on the head, a smile,...and then a wink.
14
15
16
17
18
19
20
21
22
23
24
25
26
27
28
29
30
31
32
33
34
35
36

Tony

Tony, an ambitious, aggressive, fast-talking, company employee at his first company convention, talks to a fellow employee.

1 Tell me somethin', you've been to these com-
2 pany conventions before, Bob. What's goin' on?!
3 Everyone seems so — uptight. I mean here we're
4 all finally gettin' away, right? Out of our offices,
5 escapin' the day-to-day, nine to fives. All that
6 regimental crap's behind us. Right? Arrive here,
7 the tropics, lush, green. Picture perfect, s'a pic-
8 ture perfect set up, right? Am I right? Paradise.
9 Networking dream. *(A sly whisper)* Think of the
10 possibilities, Bob. A smorgasbord of opportuni-
11 ties here. I mean anybody who's anybody in this
12 company's....
13 Alright-alright, so this afternoon, at lunch,
14 I'm standing on the buffet line; trying to make
15 some conversation with this CEO from Idaho.
16 Forgot his name. Just.... just wanted to be
17 friendly, y'know, pick his brains. Show him a lit-
18 tle bit of our New York, nice guy, energy. An' so
19 I'm yakkin', talkin' 'bout God knows what, when
20 he just like up an' walks away. Middle of my
21 sentence. Yeah. No goodbyes, nothin'. Leaves the
22 line. I stood there, dumbfounded! Where'd he...?
23 What I...? Finally, I just figured, OK, s'his prob-
24 lem, forget-about-it. Turn to the next guy in line.
25 Start talkin' to him. Some big mockity-mock
26 from the midwest branch. So I'm talkin', right?
27 Being friendly. No agendas, just chit-chat.

1 Talkin' about our office in the city. Kiddin' him,
2 y'know, tellin' him we're gonna, "Beat your
3 asses, be number one in the company." Kiddin'
4 y'know, just kiddin'. Minute later, this guy, the
5 second one, also walks. Middle of my...? Doesn't
6 even excuse himself, nothin'. I couldn't.... Then
7 two or three more! Yeah, different guys — same
8 thing. Finally I figure to hell with 'em. I ate
9 alone. They're all too uptight here. Y'know what
10 I mean? Far as I'm.... Bunch of jerks. Who needs
11 'em? Hey, where you goin'? Where you going?
12 Bob? *(Calling to him)* Bob?! Hey Bob, where you
13 going?!
14
15
16
17
18
19
20
21
22
23
24
25
26
27
28
29
30
31
32
33
34
35
36

Nate

*Nate, a gay man, recalls
a funny incident that occurred late one
night while he was drunk in a bar.*

1 Shoulda' seen me sitting there, cigarette
2 hanging from my lips. Oh I was gone, out of it.
3 Been out with my friends drinkin', havin' a good
4 time. Par-ty! We'd all gotten plowed, went over
5 to the bar. I went directly to that sleazy back
6 room there, joined in the feeding frenzy in the
7 dark. Musta been in that back room there for...
8 I dunno, who knows? Long time. Had just stum-
9 bled out. Was kind of a mess I guess. Found a
10 bar stool, sat down, looked over, saw this guy,
11 other side of the room. Cute, very... Made eye
12 contact, smiled. He smiled back. We began cruis-
13 ing each other, intensely y'know, eyeball to eye-
14 ball for all it was worth. This went on for, I don't
15 know, a long time. 'Til suddenly I realized, this
16 guy across the room, one I'd been cruising for so
17 long — was me!
18 *(Smiling)*
19 Yeah, my reflection, mirror on the wall; been
20 cruising myself! Cracked-me-up! I mean can
21 you...?! Thought it was like the funniest...!
22 Almost fell off the bar stool I laughed so hard. I
23 mean can you imagine?! Funny. Man, was that
24 funny. Boy, did I laugh!
25
26
27

Ron

Ron has driven with his parents to visit his sister and her new husband at their new home in the country. He anxiously tells them about what has just happened in the car ride there.

1 *(Upset, anxious)*

2 So Mom was talkin' a mile a minute. Y'know
3 how she does? An' pop, pop couldn't get a word
4 in edgewise. Who could? You know mom, always
5 answering her own questions. Y'know, "What do
6 you think he'll be like?" — "Sure he'll be nice."
7 "Think he's tall?" — "Bet he is." Like that, ya
8 know. Ba-bop, ba-bop, and on an' on. Rattling
9 away, the whole ride up. Nervous, excited,
10 thrilled; we all were! We couldn't wait to get
11 here! I mean, first hearing about you two meet-
12 ing in Mexico, then falling in love, getting mar-
13 ried. This trip was definitely a big deal.

14 All right, so we were just a few miles outta
15 town. And there was this road. This small...
16 round an' round, corners and curves. Was like a
17 hill or mountain, I dunno. All I know was there
18 were no lights, no lights anywhere. And we took
19 this whatever it was, hill or mountain to the top.
20 I was lookin' out the window, watchin' the snow
21 fall, my mind miles away. Half listening to Mom
22 yack, Pop tryin' to talk, the radio. And I remem-
23 ber the moon had just gone behind a cloud. And
24 I notice it's pitch black out there; couldn't see a
25 thing. An' maybe, maybe there was ice on the
26 road, I dunno, but like all of a sudden, all of

1 sudden, the car starts to skid, yeah, slide down,
2 the other side. An' Dad, well the car was a
3 rental, so maybe he just.... maybe he just didn't
4 know how.... All I know was we were goin'
5 down, fast! Very, very fast! Mom stopped talking.
6 Pop said, "Oh no!" We started sliding, skidding!
7 Pop kept turnin' the wheel, fast as he could, both
8 ways! But the car was out of control! We were
9 going down! Down into the dark, pitch black. 'Til
10 I think we hit a guard rail, I heard a crack! Then
11 we went through, over. Then we started to fall.
12 Falling. Falling! Falling, fast! And all I could
13 think was, "Oh God, NOT NOW! Not now, no!"
14 Then crash, we crashed! Glass! Things flying,
15 bouncing everywhere! Everywhere! *(A beat, softly)*
16 And then, then — it was over. The car just
17 stopped. Suddenly it was still, quiet. The only
18 sound — some crickets outside. Oh yeah, and the
19 horn, the damn horn. Like one long...! I looked
20 over, saw them, Mom and... No one screamed,
21 isn't that...? I mean you'd think some.... Was just
22 that sound, the horn. The damned horn. So
23 damned loud!
24
25
26
27
28
29
30
31
32
33
34
35
36

Sollie

Sollie, a successful business executive, recalls a terrifying moment in his life.

1 Nothing! Nothing mattered, Tom. Back then,
2 nothing mattered at all. Back then I couldn't get
3 enough. Was a real liver, a live wire! And as for
4 work, well, I was "ambition personified"! Man
5 with a mission. Totally focused. Totally! Couldn't
6 stop me, no-no-no! Pass all the bodies on the
7 road, Go-go-go! Whatever it took, anything!
8 Then, of course, came the perks. You know,
9 you work hard, you're rewarded. S'the American
10 way. Cars, expense accounts, raises up the
11 wazoo. Best of everything! Life as it should be
12 lived! A beautiful wife.... You've met my wife,
13 beautiful, right? And we got two picture-perfect
14 kids NOT on drugs. Nice penthouse, overlookin'
15 Manhattan. Whole magilla, everything! S'like out
16 of a magazine. Bibbity-bobbity-boo, "the Ameri-
17 can dream"!
18 But part of the picture they never discuss,
19 thing they never tell you, always have to be one
20 step ahead of everyone, Tom, always! Or...well,
21 so one day you wake up, put on your silk shirt,
22 Armani tie, two thousand dollar suit, go to the
23 office, have your coffee, look around — and it
24 begins. Your day has begun. Slowly you feel the
25 worry, tension, stress. Slowly, inside, you start
26 to run. Move fast, then a little faster. You look
27 around, can feel them catching up. Little faster.
28 Little faster! Find yourself out of breath. Not as

1 young as... Huffing! Puffing! Faster! Looking!
2 Looking! Running! Looking! LOOKING! RUN-
3 NING! RUNNING!! *(A beat)* Until...until that day,
4 Tom. Remember? That day, last year, right after
5 lunch. Sitting at my desk. Thought it was just
6 indi...A pain! My chest. Down my arm. Reached
7 for the phone...That's when it happened. The
8 horrible...pain. Terrible pain, Tom. Then dark,
9 s'all I remember. Pitch black. Very, very dark.
10 No more running...No more looking...No
11 more...no more anything.
12
13
14
15
16
17
18
19
20
21
22
23
24
25
26
27
28
29
30
31
32
33
34
35
36

Sollie II

Sollie describes a near-death experience.

1 *(A smile, softly)*
2 It's just like they say. S'just like in the damn
3 movies, I swear. Really. A bright white light and
4 long, long tunnel, just like they say; swear to
5 God. And there's wind chimes and warm, wet
6 walls. That was surprise, the wet walls. Didn't
7 expect that. Kind of clay-like, cushiony, soft.
8 Perfect, the place was perfect. Serene. Quiet.
9 And it's not so much what it was, what was
10 there, it's what wasn't, what wasn't there. There
11 was no...no wanting, OK? No needing, not need-
12 ing anything, nothing. No backstabbing, gnaw-
13 ing in the gut. No worries, regrets. Just...just
14 this nice white light everywhere. And a feeling
15 like...like everything's OK. OK, yes, content. And
16 you never, NEVER want it to end. Want to stay
17 there, that spot, forever. But then suddenly, it
18 like comes on you. Suddenly you know, you
19 have to choose. A decision must be made. Yes.
20 No. Move on. Go back. Choose! Was then, that
21 moment, I realized. Was then it dawned on me,
22 that the only thing that ever really mattered I'd
23 missed. It had all passed me by. I mean here I'd
24 been busting my chops, year after year, trying to
25 get ahead, move up, make more money. I mean
26 you know me, I would have killed for a promo-
27 tion! Would have...! And it's all a bunch of crap.
28 A joke! It's all...So at that moment, I chose to

1 come back. For my family; my wife and kids. I
2 haven't given them the time of day for years. I've
3 been the perfect nonexistent father. A role model
4 for unloving husbands. My kids hardly even
5 know me. And my wife?! That's why I'm walking,
6 why I'm quitting. I want to go "home," meet my
7 family, hug my kids. Second chances come just
8 once, if at all. Life's too short.
9 I'll get by. I'll be fine...I'll leave the key to my
10 office with my secretary.
11
12
13
14
15
16
17
18
19
20
21
22
23
24
25
26
27
28
29
30
31
32
33
34
35
36

Reade

Reade desperately tries to get rid of the woman who has used him as a sex object.

1 *(An angry tirade)*
2 What? What do you want?! Why are you here
3 again, huh?! I thought we...We said it was over.
4 Over, remember?! As in no more. As in you don't
5 show up here whenever you want; not anymore.
6 No, don't look at me like that. It won't work.
7 That look won't work anymore. That routine is
8 stale, over. Now just get out! Out! Leave! ...Look
9 Louise, I've got a new girlfriend now. I've moved
10 on, there's another woman in my life. And we
11 have a "real" relationship. I told you, that look
12 won't work. And you know why? I'll tell you, I'll
13 tell you why. I've finally found respect, yeah,
14 self-respect. I like myself. I "love" myself, Louise!
15 And I'm in a healthy, "mutually loving" rela-
16 tionship. I'm off your leash. I'm free! I've got a
17 woman who loves me, and I love her. A woman
18 who cares for me, talks to me. Listens, she lis-
19 tens, Louise! My new girlfriend listens to me!
20 You, you've never heard a word I said. You were
21 only interested in what you had to say. I mean
22 let's face facts, the only time we ever talked,
23 really talked, was when we made love. And that
24 wasn't conversation. That was instructions, your
25 instructions. "Do this." "Do that." "Yes!" "No!"
26 "Higher." I know what I was to you. I know
27 exactly! But that's over now. I've got... What are
28 you doing? Put your blouse back on. Put that

1 on! I'm not.... Forget about it! I'm not...! Did you
2 hear...?! Standing there seductively like that
3 doesn't do a thing. Doesn't turn me on. I'm in
4 love; I'm immune.
5 Will you please put your blouse back on? Do
6 I have to go over there...? *(Weakening)* C'mon
7 Louise, put your skirt back on. Leaning there
8 like that doesn't.... Don't move like that. I've got
9 a girlfriend. She loves me. She's my whole...!
10 Where'd you get those? I never saw those
11 panties before. They're very... Is that Mickey
12 and Minnie Mouse? *(Looking a little closer)* Louise,
13 that's obscene! What they're doing... Only you
14 could find a pair of panties.... *(Smiling)* Walt Dis-
15 ney would turn over in his grave! *(Half-hearted-*
16 *ly)* You really should leave, before it's too late.
17 Ellen will be here.... *(Smiling)* I always liked
18 your sense of humor. *(Looking at her)* You want a
19 hanger for those? You sure? *(Starts to slowly*
20 *unbutton his shirt.)* I love little Minnie's polka
21 dots. You know I really don't have to answer the
22 door. I could tell her I went for a walk, a long
23 walk. She'd never.... Don't worry about her.
24 *(Continuing to unbutton his shirt, looking a her, smil-*
25 *ing)* Ummm. Yeah...Ummm. Yes...
26
27
28
29
30
31
32
33
34
35
36

Duncan

Duncan has joined a cult that he feels has saved his life. Here he tells his estranged wife about it.

1 *(Smiling, sincere, sitting opposite her)*
2 Perfection, yes. As good as it gets. Every-
3 thing! Every thing, hon! Every hope, every
4 dream. And it's all here. And it happens almost
5 immediately! Well, actually it took me a few
6 days, maybe a week. I don't want to mislead
7 you. Want to be totally aboveboard, totally truth-
8 ful. Only the truth, that's what they tell you
9 here. My days of lying are done. You can depend
10 on that. You want more coffee? No? Sure? I
11 can.... You sure?
12 You look great, you do. I'm glad you came. I
13 am. Means a lot. I didn't.... I really didn't think
14 you would. I know how you are about.... So how
15 are the kids? ...Yeah? Good. I'm gonna call them,
16 I am. And we'll all get together again soon, yeah.
17 Honey, I'm learning a lot here. They're teach-
18 ing me so much. I'm seeing my mistakes, what
19 went wrong. It all has to do with energies and
20 bio-energies and world rhythms! I was just out
21 of rhythm all those years! That's why I did all
22 that stuff, kept getting arrested. I was
23 "unaligned." And here they help you, help put
24 yourself back into alignment. That's the secret,
25 "realignment"! And once I am, "we" are gonna
26 celebrate, you, me and the kids!
27 *(Leaning in, even more sincere)* Listen to me.

1 These folks are on to something. This is very dif-
2 ferent from those other groups. They were just
3 "cults"! But now I realize they were steps, nec-
4 essary steps, "stairs" I needed to climb, that led
5 me here. And here is home. These are friends.
6 And these friends have led me back to you and
7 the kids. Big emphasis on family here. They
8 made me call you, they did. Made me realize I
9 want my family back! That's why I asked you to
10 come today.
11 Now all I ask, all you have to do is go
12 through that door, meet them, that's all. Meet my
13 friends. Walk with me, like we did down the aisle
14 that day. They're dying to meet you. Honey,
15 there's happiness here. No need for drugs any-
16 more. Solutions, not problems. People filled with
17 love. They want to meet you, my wife, the
18 woman I love. All I ask is that you listen, hear
19 them. Open your heart to them, like you did to
20 me. That's all I ask. *(He stands up, looks at her, puts*
21 *out his hand.)* Come on, stand up — for us! Do it
22 for you, me and the kids. Come on... come on,
23 stand up, they're waiting.
24
25
26
27
28
29
30
31
32
33
34
35
36

Carl

Carl, upon being reunited with his father, recalls a day they spent at an amusement park.

1　　Roller coaster, cotton candy. What fun we
2　were having, remember? Everything seemed...
3　You were smiling, gave me a big kiss on the fore-
4　head. For no reason. Just stopped and... We
5　were walking, remember? Trying to decide on
6　the next ride. "Which one, Carl?" Then you
7　kissed me. "What do you want to go on next,
8　kid?" I was looking around, trying to make up
9　my mind. Loop-de-loop? Caterpillar? Couldn't
10　decide. So we kept walking through the crowd.
11　I was holding your hand. Good, secure, tight.
12　Just me and my dad. Perfect. A sunny Sunday
13　afternoon. Coney Island. Music, people, penny
14　arcade. Cotton candy in my hand. We had just
15　gotten off the Cyclone, remember? Three times
16　in a row. And I was trying to make up my mind,
17　looking around. And then when I turned to you,
18　to tell you, to tell you I'd made my decision...
19　When I looked up — you were gone. There was
20　no longer a hand to hold on to. I dropped the
21　cotton candy, looked around, then ran through
22　the crowd. "Dad! Daddy!" Was like one minute
23　you were there, holding my hand, and the next...
24　Passing people, pushing through the crowd.
25　What would I tell them? "I don't know. I don't
26　know where he went. Where do we live? I don't
27　know, a million places. We move around a lot."
28　Houses without numbers, streets without names.

27

1 "We travel, me and my dad, he's a salesman. My
2 mom? She's in heaven. She died." Houses with dif-
3 ferent numbers, families with different names.
4 "He'll be here any minute. He just got lost! HE'LL
5 BE HERE!" But no, you never showed up, did you?
6 DID YOU, DAD?! New families, new friends. You
7 just disappeared! You fell off the damn planet! Why
8 didn't you come find me, huh? See, I just wanted
9 to tell you.... All these years. What I wanted to tell
10 you was that I made up my mind.... Remember?
11 "Which ride, Carl?" ...Ferris Wheel. See? I decided.
12 I want to go on the Ferris Wheel, Dad. I want to go
13 on the Ferris Wheel!
14
15
16
17
18
19
20
21
22
23
24
25
26
27
28
29
30
31
32
33
34
35
36

Peter

Peter has just been through a very emotional mid-life experience. Here he tries to tell his wife what happened.

1 Something...something happened out here on
2 the balcony while you were inside, unpacking.
3 *(He looks out for a moment, then, turns back to her)*
4 I was standing here, balcony doors were
5 closed. I was watching the fireworks. Just.... I
6 don't know, enjoying the night. Nice. Thinking,
7 maybe Meg's right. Coming here, good idea. The
8 two of us, Disneyland. Together. So I'm standing
9 here, looking out, when suddenly I felt like a
10 chill. Like a cool.... I turned and...it felt like I
11 wasn't alone. Was like there was something else
12 out here. Nothing I could see or touch. Just a
13 feeling. *(Becoming agitated)* I started moving,
14 frightened, pacing back and forth — fast. Could
15 feel it, following me from one end of the bal-
16 cony.... *(Building)* I called you, your name, sev-
17 eral times. But it was like my voice had no
18 sound. Nothing seemed to... Finally, I stopped
19 pacing. Just — stopped, suddenly! Sat down in
20 the chair, pulled my head in like this, covered it
21 with my hands. I was trying to hide; hiding
22 from.... But I could feel it, circling me in the
23 chair. Going round and.... I was like a baby in
24 a bubble, a target. And it kept circling, closing
25 in...! *(He stops himself)* When I had this thought,
26 remembered this phrase — "What you.... What-
27 ever you resist — runs you. What you resist —

1 persists." And at that moment, right then and...I
2 just — gave in, gave up. Lowered my hands,
3 opened my eyes, sat straight up in the chair. Let
4 it.... Allowed.... Stopped. Stopped resisting! I
5 just.... I needed to be alone, to sit with, to final-
6 ly accept.... *(Softly)* middle age. That's what it
7 was Meg, middle age. It found me, here, on a
8 chair, on a balcony overlooking Disneyland on
9 my fiftieth birthday. Middle age — cornered me,
10 then covered me — like a brand new layer of
11 skin.
12
13
14
15
16
17
18
19
20
21
22
23
24
25
26
27
28
29
30
31
32
33
34
35
36

Harvey

*Harvey, drunk and obviously upset, tells
a bartender about an incident that
occurred at work a couple of hours before.
At his feet is a leather case.*

1 *(Loud, angry and aggressive)*

2 No! S'not! S'not about money! Not with them

3 um-um, no-no, not money. Money's got nothing

4 to do with it! S'bout clout, control. They don't

5 give a hoot, not a half a hoot about us! Not them,

6 no! All that bowing, brown rice is.... Hey, give

7 me another drink, will ya? Dewars, 'nother

8 Dewars! And don't drown this one with an ice-

9 berg. Just a couple of cubes this time.

10 *(While waiting, a little calmer)* Alright, so I get

11 up this morning, nice day, beautiful. Didn't have

12 a care in the world. Get to work, and Siegel, my

13 boss, asks me to come into his office. Sure, no

14 big deal. I walk in, he seems tense.

15 I say, "What is it, sir? Something wrong?"

16 He gets right to the point. Says our Japanese

17 associates, company's biggest clients, have found

18 it "exceeeedingly" difficult to work with me.

19 "With me?" I say.

20 Says they told him I was, "rude, bullligerate,

21 unprofessional and obviously prejudiced."

22 "Me?!" I said again. "There must be some mis-

23 take here, they couldn't have said that about

24 me?"

25 He's reading all this from a book, mind you.

26 They kept a journal, the Japs. And he's reading

31

1 from it, incident after incident. Pages, chapters.
2 I'm standing there, listening, feeling crucified!
3 Seems they monitored my every move, the Japs.
4 He goes on and on, reading from their book;
5 back to Hiroshima for all I know! I mean if I lost
6 a paper clip, if I farted, them Japs had it marked
7 down in that book! Suddenly it hits me, the axe
8 is about to fall.
9 When Siegel finishes reading, he looks over
10 at me with those marble-like make-believe eyes.
11 I felt like I was floating, like my arms and legs
12 were starting to disappear. He walks over to the
13 window, looks away. Says what a beautiful day
14 it is. "Yeah," I said, "beautiful." Then all I
15 remember were a few of his words. "Let go,"
16 "severance," and "sorry." It was over, I was
17 fired. Where's that drink, huh?
18 *(Beat)* I floated out of there, walked for hours,
19 miles. Saw your bar. I'll tell ya something. *(He*
20 *smiles, a whisper.)* Not everything's made in
21 Japan.
22 *(He slowly lifts his case up to the bar)*
23 Maybe they got Siegel, them Japs, but they
24 didn't get me. *(A big smile)* And someone...some-
25 one's gotta save America! And I got some toys
26 here. Toys, made in America. Toy guns, toy
27 ammo.... 'Cept they're not "really" toys. And it's
28 not really over till the fat lady sings. And she
29 hasn't sung yet. What the hell are you looking
30 at? Just get me my drink. Did you hear me? I'm
31 in a hurry. Get-me-my-drink!
32
33
34
35
36

Frank

Frank recalls his big movie break.

1 I'm at the top of the staircase. The queen's
2 down at the bottom looking up at me, afraid,
3 frightened. I pull out my sword. "Fear not, my
4 queen," I say, "The castle is not lost, not yet!"
5 They start coming at me, must be a dozen of
6 them, the evil sheriff's men. Clang, clang, clang,
7 I start fighting them off, one by one, working my
8 way down the stairs. Feel like Errol Flynn. The
9 fencing lessons have paid off. "Coming, my lady,
10 fear not!" Cameras follow my every move. My
11 concentration, totally focused. Clang, clang,
12 clang. "Away you scags!" I deliver each line
13 exactly as we rehearsed. A hero's confidence, a
14 star's charisma. The stunt guys on this one are
15 terrific. Then, after each take, the director yells
16 out, "Cut! Cut! Perfect!" I smile at him. He smiles
17 back. Yes! Yes!
18 We shoot the scene for almost two weeks,
19 twelve, thirteen hour days. We're at the last part.
20 I've killed off the bad guys, I bow before my
21 queen, humble, exhausted. She looks down at
22 me; her close-up. I kiss her hand; the camera
23 closes in, my close-up. Zoom to her, tears in her
24 eyes. She looks at all the fallen stunt soldiers
25 and says, "So sad. So sad, so many dead." Then
26 she turns, goes to window, looks out. My final
27 close-up. The director yells, "Cut! Cut! Perfect!"
28 It's over. The film's in the can. It's all paid
29 off, yes, finally. The acting lessons, speech classes,

1 auditions, rejections, all of it. The years, the
2 struggle. Finally. Finally.
3 The film opens; big opening. Red carpet.
4 Everybody's there. Seems like the whole town
5 has turned out. Congrats! Congrats! Kisses on
6 the cheek. Agents, casting directors. "I didn't
7 know you were in this, Frank." I'm modest, say,
8 "Just one scene." The director gives me a big
9 hug, a smile. I know everything's OK. Flash-
10 bulbs, photographers, looks of awe from
11 strangers.
12 I'm there with my wife and mother. We're all
13 dressed up. Rented tux, gorgeous gowns, jewelry.
14 I can't wait to see it, the movie. You know
15 how he is, the director, secretive, he only gives
16 you the scene you're in. But I'm not worried, I
17 mean he's a great filmmaker.
18 We go in, sit, lights down, it begins. I agonize
19 through the first hour or so. It's brilliant, of
20 course. Sort of like a Robin Hood meets *Star*
21 *Wars*. Pyrotechnics, special effects, but with a
22 richly dark, comedic, cynical twist. Destined to
23 be a classic, I think. Then...then, there it is, my
24 scene. There I am, at the top of the stairs. My
25 wife clenches my hand, my mother finally stops
26 fidgeting. There I am! And I look great! I'm
27 sorry, I just have to say it, the camera loves me.
28 I pull out my sword, stand there, defiant! The
29 camera starts closing in, then — zap! What the
30 hell was that? Some kind of laser. That wasn't....
31 They quickly cut to the queen at the bottom of
32 the stairs. Tears in her eyes, she looks at the fall-
33 en men. What happened? She says, "So sad. So
34 sad, so many dead." What?! She turns, goes over
35 to the window. What happened?! Next scene.
36 Next scene! Where's my...?! My wife turns to me,

1 confused. I look at my mother, she's almost in
2 tears. I was.... "Cut! Cut! Perfect!" "Perfect!" he
3 said.
4 I sank into my seat, wrinkling my rented tux.
5 The movie continues but I become a fur ball, a
6 piece of lint on my seat. In the credits I am list-
7 ed as a "shot soldier." "Shot soldier," that's it.
8 Two weeks of my life.... I don't remember the
9 rest of the night. It's all a cinemascope, techni-
10 color blur.
11 *(A beat)* A few months later... A few months
12 later I quit the "biz." We all left L.A., moved
13 back to New York. I now own a chain of
14 women's shoe stores, doing very well, making
15 big bucks. Every once in a while, I see the film
16 on T.V. in reruns. It's really not very good. Real-
17 ly. Matter of fact... *(He smiles.)* Matter of fact —
18 it really stinks!
19
20
21
22
23
24
25
26
27
28
29
30
31
32
33
34
35
36

Joe

*Joe shares his feelings and realizations after
a painfully disturbing afternoon.*

1 (*Softly, in pain*)
2 Where'd everybody go? S'no one left. Mel
3 was.... What's happened, huh? Where'd they all
4 go?
5 (*A beat*)
6 I was walking around the village this after-
7 noon after Mel's memorial. Just.... And every-
8 where I.... Strangers, unfamiliar faces. Mean we
9 used to know everyone down here, didn't we?
10 Every shop, a hello. Every bar, every bartender.
11 Couldn't pass a store without knowing someone
12 inside. S'all changed. Kept walking, block after
13 block, looking, no one. Went over to the piers.
14 Was crowded. Lotta people there, but no one, no
15 one I knew. Saw faces that looked somewhat
16 familiar, but they were just look-a-likes. Then I
17 realized, dawned on me, no one's left. They're all
18 dead, all our friends, everyone. AIDS. S'become
19 a city of strangers! S'like I'm a tourist here, vis-
20 iting the Village, wondering, "Who are all these
21 people?" Who lives here? Who lives here, huh?
22 (*Continuing, becoming more agitated*) Kids who
23 come into our shop every day, haven't you
24 noticed? All of 'em, new faces — replacements!
25 I'm tired of crossing off names! Pulling full
26 pages from our phone book! Condolence
27 cards...! Memories! WHO'S NEXT, HUH?! Memo-
28 rials! WHO'S LEFT?! WHO, HUH, WHO?!

37

Tom

*Tom talks about a recent mountain climbing
experience that changed his life.*

1 *(Looking up)*

2 What could be more romantic, right? Hap-
3 pened up there, at the top. From up there you
4 can see everything. Everything, believe me.

5 We started up early, about eight. Figured it
6 would take four, five hours. Be up there 'bout
7 noon, y'know? That's where I was gonna do it.
8 Down on my knee, up at the top. What could be
9 more romantic, right?

10 But from the get-go, she's a little hesitant, lit-
11 tle scared. Doesn't want to go. Says it's too high,
12 wants to go home. I try to encourage her, but
13 she says, "No." I begin to plead, "Please, baby,
14 do it for us." And she looks at me, smiles that
15 smile of her. Says, "Alright, for us." She gives in
16 and we go.

17 The climb's easy at the bottom. No big rocks,
18 plenty of places you can dig your feet in. And
19 pretty soon she's really into it, we're havin' a
20 ball. We're like two kids at camp. Climbing,
21 singing songs, "A Hundred Bottles of Beer on
22 the Wall." Every step an adventure, every cliff
23 getting us closer.

24 We hit the top a little after noon, just as I pre-
25 dicted. And she's "ecstatic," has a sense of
26 accomplishment. She overcame her fear! And I
27 was so proud of her.

28 So we're up there, lookin' down, enjoying the

1 panorama, the endless.... That's when it hap-
2 pened! All I can say is it never happened before.
3 And I've been climbing.... Was like my legs were
4 suddenly made out of jelly. My stomach... I
5 thought I was gonna heave. Was like my body
6 suddenly had no weight. Like a good wind could
7 just blow me off that cliff and I'd fall all the way
8 down. What I'm trying to say here is — I was ter-
9 rified! I've never been so scared. Things just
10 don't scare me! I mean where I'm from....
11 She looked over at me, asked if I was OK. I
12 tried saying "Sure!" in my usual way. Y'know
13 like "Sure! Sure!" But I couldn't. My teeth were
14 chattering. "What's wrong?" she asked. No
15 words, I couldn't speak. She came over, put her
16 arms around me. "Tell me Tom, what is it?" I
17 couldn't move, couldn't talk. I was shivering.
18 This was definitely not my plan! I was gonna
19 propose! She was gonna say yes! We were gonna
20 get married!
21 She said, "Let's go back down, I'll help you."
22 I guess I said yes, leaned on her, and we left.
23 Then step-by-step, little baby steps at first, we
24 started going down the mountain, her almost
25 carrying me. Step-by-step, step-by-step, seemed
26 forever. But the farther we got away from the
27 top, the better. When we got down that first cliff,
28 I started feeling almost like my old self. But this
29 time going down we hardly talked, hardly said
30 a word. No songs this time, I'll tell ya. She'd ask
31 me how I was and I'd mumble, "OK.," "Fine." We
32 finally got down to the bottom. Seemed like it
33 took forever. We came here to the parking lot to
34 get the car. And that's when I thought, "Hey,
35 why ruin a perfectly good day?" And you know
36 what I did, know what I did then? Got down on

1 my knee, asked her to marry me. Right here, this
2 spot. Wasn't exactly where I planned but.... I
3 looked up and asked her. After a moment, she
4 said, "Yes! Absolutely! Of course!" Then we
5 kissed. Right here, this spot!
6 *(A beat)*
7 She'll be back any minute. Like you to meet
8 her. Just went to the ladies room. *(Smiling)* Just
9 so you know, there's no toilets on the way up.
10 We're going back up there, yeah. Gonna give it
11 another try. Sure! *(Looking up)* We're even think-
12 ing of getting married up there. Yeah, up there,
13 way on top. It's amazing up there. And after all,
14 when you think about it — what could be more
15 romantic, right?
16
17
18
19
20
21
22
23
24
25
26
27
28
29
30
31
32
33
34
35
36

Clark

Clark, a formerly successful commercial actor talks about his career.

1 You book, book one and you're hooked.
2 Hooked, my friend! Believe me, I know. The
3 enticement, exposure! Book two or three and
4 you're on a roll. Floodgates are open! Mister
5 mailman and you become best friends. He brings
6 you truckloads of long white envelopes filled
7 with long blue checks. Many, money, your mail-
8 box overflows. Hello, hello! from Vanityville. You
9 become the new thirty-second star. Walk down
10 the street and now people know you.
11 "Aren't you...."
12 "Yes."
13 "Didn't I just see you...."
14 "Yes, you did."
15 You've convinced them, they believed you.
16 They think you found God in a bottle of Lysol™,
17 that you had an Epiphany with a fat old cat and
18 a can of 9 Lives™ cat food. I was on a roll! Back
19 then I bathed in a bathtub of residuals.
20 *(A beat)*
21 But you learn, as I did, that all kingdoms
22 have rules. Fame is fickle, and instant royalty
23 can suddenly fall, and fast. For instance, you
24 learn that if you block the product the client will
25 see that you're deported. And the penalty's
26 much worse if you become, as I was — "overex-
27 posed." I became a "once was," a "used to book."
28 It went as quickly as it came. Hey, I know I'm

1 still young, a kid. But in this industry it's book fast,
2 die young. Now, no one even knows me. My career's
3 over; ended suddenly. Hell, they won't even let me
4 pitch a bag of potato chips. Not even a voice over,
5 a demo, nothing! I thought it was going to last for-
6 ever! Today, when I watch T.V. — I cry at the com-
7 mercials. "I coulda done that. That shoulda been
8 me!" Coulda-woulda-shoulda. I was big, big! Proctor
9 and Gamble loved me! Hey, I was the guy in the
10 Volvo spot, remember? The Ragu™ guy? Me.
11 Jockey™ shorts? Right here. Cheerios™? Big! BIG!
12
13
14
15
16
17
18
19
20
21
22
23
24
25
26
27
28
29
30
31
32
33
34
35
36

Warren

*Warren talks with the sheriff about a tenant
of his who has mysteriously disappeared.*

1 Just like that, snap, poof, gone! I have no
2 idea how it happened. Man just disappeared.
3 One minute he's sitting there, that chair, watch-
4 ing T.V. I turn to say something, he's gone,
5 chair's empty.
6 I call out, "Mr. Fishbein! Mr. Fishbein?" No
7 answer. I was perplexed. Seemed strange.
8 "Mr. Fishbein?!" Not a sound, not a peep,
9 house was empty. Thought maybe he went for a
10 walk. Did that before, long walks in the woods.
11 But then a loud noise outside. I run to the win-
12 dow, look out. Bright light, very bright! Thought
13 it was an atomic explosion. I turned away it was
14 so bright. And when I looked back, it was gone.
15 I ran outside. Nothing, just stars, moon, night.
16 Didn't no one else see or hear nothing that
17 night?... Nothing? No? Well I sure did.
18 Fishbein was a good boarder, nice guy. Quiet
19 man, never made no trouble here. A stay-at-
20 home, a T.V. watcher. A to-himself. I know, peo-
21 ple talked, said he had a lot of money. That he
22 was a rich Jew. Way he dressed, I guess. People
23 in town talk. But I never saw none of it, never.
24 I just got my weekly rent, which he paid, pron-
25 to, on time, Mondays.
26 ...What? Yeah, I did fix up the house a bit.
27 Looks good, huh? It needed some work. How?
28 Mr. Fishbein...gave me some extra cash, few

1 weeks ago. A little gift. Wanted the place to look
2 good, he said... How much? I don't know, couple
3 of thou. Wanted the place to look nice. He was
4 planning on staying here. Loved the woods,
5 nature.
6 You mean there haven't been any reported
7 sightings, U.F.O.s? No? What? This watch? Watch
8 was a gift.... Yeah, Mr. Fishbein gave it to
9 me...My birthday, a month ago. Is it? No kiddin'.
10 That expensive? Really? I had no idea. I'll be
11 damned. Guess he liked how I made up his
12 room, took care of him. He...What? Sure. Go
13 ahead. Look anywhere you want. There's miles
14 and miles of woods out there. Look anywhere
15 you want. I got nothing to hide here. He was just
16 a rich Jew who stayed in one of my rooms for a
17 while, that's all. Far as I know he left. How and
18 where is really the question. But as far as I'm
19 concerned he was just a tenant who stayed here,
20 a boarder, a to-himself.
21
22
23
24
25
26
27
28
29
30
31
32
33
34
35
36

Don

*Don tries conning an innocent actor into a
movie deal.*

1 *(A fast talking con artist)*

2 Tell me, aren't you tired of being on the back

3 burner? Isn't that really why you are here, huh?

4 We can make it happen, the movie you've always

5 wanted to make. Your movie! There's that story,

6 you know, the one you always had in the back

7 of your mind. One that would haunt you. One

8 you'd say, "God, that would make a great movie.

9 If only.... If only...." Well that's why you're here.

10 "If only" is now!

11 So we start shooting, you're the star, got total

12 artistic control. You give the performance of

13 your life! Film shoots a breeze. Sure it's a lot of

14 work, but it's exhilarating, empowering! Then,

15 after, you help with the edit, to make sure that

16 every inch of you and your talent shows, is high-

17 lighted. Then the film festivals. Parties. Kudos.

18 Applause. "Bravo! Bravo!" Standing ovations.

19 Distributors giving you their cards. Everyone

20 wants to show your movie. Your movie! They

21 call you the next Coppola, the new Orson Welles!

22 "Bravo! Bravo!" After years of being just anoth-

23 er trying-to-make-it actor, you've finally entered

24 the fast lane. World's at your feet, dice are in

25 your hand. Where shall we go today? Get the

26 picture? *(Smiling)* No pun intended. You're on

27 the cusp of a dream here. Look, I know the peo-

28 ple, you just yes. I pick up that phone, we go

into pre-production. Don't worry about the money, you can pay me in small payments. Weekly, monthly, I don't care. Believe me, it's not about the money.

So — is that a yes I see in your eyes, or is that just "stardom"? Say it. Say the word and we start. Say yes — and we go!

Paul

Paul, the victim of a plane crash, has been stranded on a deserted island for several days. He thought all the other passengers were dead, but has just discovered another survivor. He's exhausted, a bit crazed, and desperately trying to get the injured man to respond to him in some way.

1 *(Leaning in to the man)*

2 If I walk away, if I leave you here mister, you

3 won't ever move again, believe me! If I leave you

4 on this beach, you won't budge. I'm your

5 last...you'll lie here...you'll wallow here in your

6 own whatever. 'Til you fall asleep. Yeah. Dan-

7 gerous, sleep, believe me. Believe me, I know

8 I...you'll find yourself lost in a stream of memo-

9 ries. Know all about that, too. Hey, I know you

10 can hear me! Don't close your eyes on me! Don't

11 you dare! Alright, so pretty soon, pretty soon

12 mister, lying out here in the elements, you'll be

13 overwhelmed. Be flooded, be soaked. The ocean

14 will... And as wet as you get, you'll soon become

15 parched. You will die, you hear me?! Become a

16 corpse, a cadaver, remains. And all that'll be left

17 of you will be memories, mister. But not yours,

18 no. You'll be gone. Be mine, my memories. See,

19 I'll be stuck with the thought of you. And I've

20 already.... Everyone else.... *(Looking around)* All

21 dead. We never got to Florida. Fun in the sun!

22 Yeah, ha! S'just you and me out here on this

23 beach. Move something, will you? An arm, a leg.

1 Blink. Blink, damn it! ...Good. Good boy.

2 *(Looking out, softer)*

3 Ocean's calm today. Should have seen it yes-

4 terday. Jeez, was like a hurricane here. I never

5 saw...

6 Look, I'm gonna get you out of this sun. This

7 isn't good here. We gotta go... *(Looking around)* I

8 don't know, some shady place somewhere. I'm

9 gonna lift you up, OK? Only thing you gotta do,

10 all you gotta remember is to breathe, keep

11 breathing, OK? That's all you gotta do. Easiest

12 job you ever had, right? Just keep thinking

13 "alive." "Life." Think about Miami, the good

14 times you're gonna have. We'll have a drink

15 together in South Beach, OK? I'll even pay, s'on

16 me. This place here is just a little setback, a lit-

17 tle detour. We'll be in Miami in no time, you'll

18 see.

19 *(Leaning in a little more)* Hey! Hey Blinkie!

20 Let's see you blink again...Good boy. Keep them

21 eyes goin'. I'm gonna lift you up now, OK? *(He*

22 *moves in to him a bit, then stops)* Oh.... My name's

23 Paul. Friends call me Paulie. You can.... You can

24 call me whatever the hell you want. Just...just

25 don't die on me, huh? Please. Please.

26

27

28

29

30

31

32

33

34

35

36

Andre

Andre describes a crime he's just witnessed.

1 While waiting, I watched, saw the whole
2 thing. These guys, two guys on the corner, Forty-
3 Fifth and Ninth. Looked like Heckel and Jeckel.
4 Wearing colored pins, rhinestones, dressed all in
5 leather. Well, Heck and Jeck were coked up,
6 puttin' the moves on this Mister Rigid; this busi-
7 nessman in a suit, whose family was probably
8 home watching *Seinfeld* in Jersey, waiting for
9 him. Mister Rigid looked like he'd had a few. He
10 was wobbly, he was prime, he was fertile. It was
11 like watching "Bambi Meets the Deer Hunters."
12 Danger. I mean you could be brain dead and
13 you knew what was going to happen next. Yeah,
14 sure, I could have gone over, stopped them, be
15 like a "Mr. Smith Goes to Washington." But I
16 took a more devious, God-like delight in seein'
17 the inevitable.
18 So Heck and Jeck were telling him jokes.
19 And he was listening intensely, his head bounc-
20 ing back and forth from one to the other. They
21 were foolin' with him, but he simply thought
22 he'd made new friends. He wasn't aware, poor
23 schmuck, that between every joke was a poke, a
24 feel, their fingers looking for the find. Till final-
25 ly, they found it, papa's soon-to-be-emptied-wal-
26 let was in Heck's hand. I mean even in the dark,
27 way across the street, I could see it. And the
28 joke, of course, is that this guy, Mr. Rigid, prob-

1 ably runs Wall Street, giving old people advice.
2 Alright, his wallet taken, Rigid suddenly
3 receives a fleeting duet of good-byes from the
4 boys. They quickly take leave of him, scamper in
5 a hurry. They leave him, laughing from their last
6 joke. But the last joke, of course, was him. Yeah,
7 sure, I could have gone over, told him what he'd
8 missed. But why? Why should I? He had been
9 had for such a good time. And maybe now, who
10 knows, maybe now he'll stay home with his fam-
11 ily in Jersey. Maybe now he'll take care of his
12 kids, kiss his wife, become papa domestic. But
13 no, I don't think so. More than likely he'll be
14 back in a week with a new wallet.
15 While waiting, I watched, saw the whole
16 thing; beginning, middle and end. And then my
17 friend finally arrived. I didn't tell him what I'd
18 seen. No point; was one of those "you had to be
19 there" kind of things. 'Sides, we were running
20 late. We were going over to Forty-Second Street
21 to sneak in to see the second act of Walt Disney's
22 epic jungle tale of survival, *The Lion King*.
23
24
25
26
27
28
29
30
31
32
33
34
35
36

Moe

Moe, living in the wilderness with his family, warms up to an unusual house guest.

1 　　I've listened, I hear you, I know what you
2 mean. And I agree, I do. I see the world exactly
3 the way you do. We're birds of a feather, bro.
4 Sure, talk's cheap I know, but your ideas,
5 beliefs, move me. I agree with every word you've
6 said. That's why we moved out here in the first
7 place.
8 　　But last Saturday, last Saturday night, when
9 you guys first showed up here, I'll tell you, you
10 put me to the test. I mean, at the least, at the
11 very least, we were all quite "apprehensive."
12 Well you saw Shirley, she went bonkers. And
13 even though I kept saying, "Shirley, just give
14 them a chance!" She...well, don't get me started
15 on her. The kids love your being here. I'm sure
16 you've noticed. Especially my little one, she
17 finds you all fascinating.
18 　　Anyway, after you showed up, I knew I had
19 to practice what I preached. Try, however hard,
20 to "accept." I mean that's why we moved out here
21 in the first place, what I've always taught my
22 kids, "acceptance." We didn't move out here, mid-
23 dle of nowhere, just to be isolated. We couldn't
24 tolerate the intolerance where we were; it was
25 intolerable. And now I know you feel exactly the
26 same, the same way. And that connects us.
27 Everything else, well, we can work it out.
28 　　And you guys are good houseguests, that

1 always makes things easier. Do your chores,
2 easy to get along with, very down to earth. You
3 don't pull any punches, I like that. Tell it the
4 way you see it. So I guess what I'm saying here
5 in a long-winded way is — we're happy you've
6 chosen us to stay with. And YES, we'll do what-
7 ever we can to help. We're with you one hundred
8 percent! All of us, even Shirley. We want to weed
9 them out, just like you. Get rid of them, the
10 racists, bigots. Eliminate them, just like you said.
11 I agree, absolutely! They've got to be stopped,
12 you're right. So anything we can do, anything!
13 Only thing I ask is that you keep a low profile,
14 OK? Just for a while. I mean...if you're expect-
15 ing like a big mother ship or some squadron
16 from space, could you just like put a nix on it,
17 just for now. Just till we get things going. All
18 that spectacle and commotion could call a lot of
19 attention to us out here. And if the newspapers
20 get wind of what you're.... I mean just one look
21 at you, well, you guys can't exactly pass for our
22 new next door neighbors, y'know. They see you
23 and this place would become media central in a
24 minute. Flashbulbs, reporters, forget about it.
25 You don't want that, believe me, believe me!
26 *(A beat)*
27 OK. That's it. End of back-porch lecture.
28 Sorry, I tend to talk too much. So, when do we
29 begin? When do we.... Tonight?! You're kidding!
30 Wow! Alright. Sure. I'll go tell Shirley and the
31 kids. *(He starts to leave.)*
32
33
34
35
36

Gil

Gil, a writer, tells about the real and imaginary world of his angst-filled night of writing.

1 Anything. Everything. Whatever it took.
2 Whatever it takes. I'd focus, then find myself dis-
3 tracted. Then return again to my desk for some
4 more rewriting, reshaping. Change a line, a
5 word. "No, that's not right!" Rip it out, start
6 again. Sit there, play frisbee with a phrase. Then
7 finally, too frustrated, I'd look out a window, pet
8 the cat, turn the T.V. on, make a kettle of tea, sip
9 it in some kind of pretending I'm relaxed, I'm
10 OK ceremony. Pretending that this isn't torture.
11 Making believe I'm just sitting here at four in
12 the damn morning, sipping some tea. Like I
13 couldn't care less. When the truth of the matter
14 is, I couldn't care more!
15 *(A beat, more relaxed)*
16 I'll tell you, you wonder sometimes. You find
17 yourself alone in your small room, sitting at
18 your desk, wondering, am I wasting my time?
19 And I know, if I stay with these thoughts that
20 all creative tinker toys and gardens about to
21 bud will close down for a long, deadly winter. So
22 I back away, rally, tell myself, "yes," it is worth
23 it! It is, because someday, someone will see this
24 I say. Someone will know I was here, someone
25 may be moved. My marker will be left on the
26 road. And I believe that, I have to. I do! It
27 encourages me. So I put down my hardly-
28 touched tea, and return to this huge tornado at

1 my desk. And I allow myself to get sucked up
2 into it. I offer no resistance, go for the ride. And
3 this tornado lifts me higher and higher! And I go
4 with it! Go! Lose all sense of myself. Allow! Give
5 up, surrender! And then when it's done, when
6 it's over — it gently, carefully spits me out. And
7 I land on my feet at my desk. It's quiet, calm. I'm
8 exhausted, exhilarated, spent. I look around and
9 find myself somewhere I've never been before.
10 The words on the pages that I've just written
11 suddenly make sense. There is a meaning I didn't
12 know I meant. I have been taken somewhere
13 and I have been returned. And where I am now
14 is where I wanted to go in the first place. Prob-
15 lem was I just.... I didn't know how to get there,
16 I guess. I am at home in my own house but the
17 furniture's been rearranged. I am at home in a
18 new place. Once again I read what I've just writ-
19 ten, and I find that I'm satisfied. So I slowly get
20 up, leave the room, go out and open the front
21 door to my house. It's almost morning. Nice day.
22 I look down at the pages in my hand and yell,
23 "Yes!" And that "yes" resonates through the
24 many rooms in my house that I've never even
25 thought about. Yes to all, yes to everyone, to
26 everything! And I take out my welcome mat,
27 place it by the front door of my house. And I
28 stand there, holding the just-written pages in my
29 hand, awaiting any visitor, any guest and, of
30 course, the new day.
31
32
33
34
35
36

Myles

*Myles shares an extraordinary life experience
with someone he has just met.*

1 Hate. Yeah, hated everyone. Everyone I met,
2 really. It was... I don't know, like some uncon-
3 trollable motor inside me. This uh, constant bar-
4 rage of judgments, dislikes, mistrust. ...Hate. No
5 one was beyond reproach, no one. The slightest
6 flaw, any defect, I'd magnify. Too tall, short, stu-
7 pid, ugly, whatever. Anything. Any inadequacy I
8 could find, and I'd focus right in on it. Could
9 only see peoples' flaws, nothing else. Each per-
10 son, a mass of blemishes. A race of misfits. A
11 planet of imperfect people. Till finally,
12 inevitably, I couldn't bear to be with anyone.
13 Eventually there was no one left in my life. No
14 friends, job, family, no one.

15 Ended up.... I ended up in this tiny fleabag
16 hotel on the upper west side. I was the king of
17 no one, seated on an imaginary throne, over-
18 looking my own self-created, solitary confine-
19 ment. And what I discovered, what I found out,
20 *(Leaning in a bit, a hushed whisper)* is that it all
21 returns to roost. Call it karma, whatever. It
22 comes back, always. Like a boomerang in the
23 night. You toss it out and then wait for it to
24 return. You live alone. Time passes. You wait.

25 Was a cold winter night late last year. I was
26 trying to fall asleep, restless, tossing in my bed,
27 in my tiny roach-filled room. And it arrived,
28 finally. Little drops at first, seeping through the

1 ceiling. Then a crash through the window. I sat
2 up in my bed, startled. Then it broke through
3 the wall. Then it knocked down my door. I was
4 terrified, it was everywhere! It had come home!
5 The room quickly filled with it. And soon I was
6 covered, it was all over me. Like a thick,
7 gooey...Hate. Hate! The smell! I screamed, I
8 called out for help, kept screaming! Then...some-
9 thing happened. It was like an atomic bomb
10 exploded inside my chest. Here, right here, by
11 my heart. The pain! Then, I guess I passed out.
12 Someone must have heard my screaming. A
13 neighbor. Called the police. An ambulance.
14 Emergency operation. They cut me open. They
15 said it was the size of a very large grapefruit. It
16 was huge, black — a huge, black tumor. Right by
17 my heart. They said they never saw anything
18 like it, one for the books. It now sits quietly in
19 an alcohol-filled glass bottle in a showcase some-
20 where in some lab, where doctors can.... I was
21 this close to death, a breath away.
22 *(A beat)*
23 Now? Nothing's the same, no. Nothing. Flip
24 side of the coin. Poison into medicine. Now
25 *(Smiling)* I see a world filled with nothing but
26 love, beauty. A place with people so perfect.... So
27 special. Unique. Wonderful. A perfect 180. I no
28 longer try to figure why it happened the way it
29 did for me, or even what it all means. All I know
30 is — I'm a lucky man, mister. Very.... You're lis-
31 tening to a damned lucky son-of-a...! But when
32 you think about it, hey, aren't we all? Aren't we
33 all really — lucky?
34 That's it. End of story. Some saga, huh? Can
35 I buy you that drink now? And you can tell me
36 all about you. Anything. Everything. I'm all ears.

Ed

Ed talks about taking his disabled girlfriend home to meet his mother.

1 I wanted my mother to meet her. Was a big
2 deal. Eileen is the most important person in my
3 life. I was nervous. I was very... Alright, stop
4 story, time to tell you. Eileen's disabled. About
5 eight years ago she took a fall. Was winter,
6 snow, ice, a flight of stairs. Her spine. She has
7 to use an electric wheelchair. It complicates
8 things, sure, but they're not impossible. I mean,
9 I've gone out with able-bodied girls where things
10 were much more unbearable. Compared to some
11 of them.... Well, that being said, when I called
12 my mother to tell her about Eileen, she cried,
13 got hysterical. My mother tends to get very emo-
14 tional. She asked, "Why, why this girl?! You
15 know what kind of life you're going to lead?!
16 People will pity you." I told her, "It doesn't mat-
17 ter. I love her, I love this girl. She's the most
18 beautiful, compassionate, considerate person
19 I've ever met. I love her and she loves me, and
20 I'd be lucky if she'd even have me." She yelled,
21 "She's crippled!" I asked her, "You want to meet
22 her or not?" She said no, she couldn't, she was
23 sorry. Said she couldn't bear to see her son
24 make such a big mistake with his life. Begged
25 me to break it off. I said, "No, I couldn't." She
26 hung up on me. I sat there and cried. Sat there
27 by the phone, crying. I'm not sure why or for
28 whom. I get very emotional sometimes. The

1 phone rang, was my mother again. She asked me
2 if I changed my mind yet about this pathetic,
3 crippled girl in the wheelchair. I told her no.
4 Told her I loved Eileen and probably would for-
5 ever. After a moment she said, "OK, bring her to
6 dinner next week. Does she eat beef?" I told her
7 I wasn't sure. She said how could you love some-
8 one and not know what she eats? "You embar-
9 rassed to take her to restaurants?!" I said I
10 thought I remembered seeing her eat a ham-
11 burger once. My mother said, "Forget about it,
12 I'll make chicken. Come at eight, take her in the
13 service elevator. I don't want any of the neigh-
14 bors to see." I said, "No-no-no, we definitely
15 would not take the service elevator. Regular ele-
16 vator or nothing!" "Service elevator!" she said. I
17 said, "No, I'm sorry, definitely not." After a long
18 pause, she said, "OK. OK Eddie, it's your funer-
19 al. I can't wait to meet her."
20 The night came, I was a wreck. I was pacing
21 back and forth, Eileen following me in the chair;
22 telling me it was going to be fine. Finally, I just
23 sat down and cried. Told you I get emotional.
24 Eileen came over to me, sat with me, told me not
25 to worry. Said it was going to be OK. I looked
26 at her. I believed her. I kissed her and we left.
27 We got to my mother's building, took the "reg-
28 ular" elevator up. My mother was standing there
29 in her apron, waiting at the door. She was smil-
30 ing a smile so big I thought both her ears were
31 gonna pop off. And I knew that smile. I'd seen it
32 a million times before when I was growing up.
33 It's the smile she uses to hide how she really
34 feels when she's hurting inside. Eileen looked up
35 at her, smiled comfortably and said, "Hello, I'm
36 very glad to meet you." She shook her hand,

1 rolled right in. Composed as ever, that's Eileen.
2 It was Waterloo. My mother stood there,
3 watched her go in. Her expression changed. She
4 kissed me, whispered, "Not bad. Pretty girl. Very
5 confident." Something in her voice, something
6 happened in that one moment that they met.
7 Right then and there I knew it was gonna be all
8 right. Dinner was... The two of them hit it off
9 like wartime buddies. They seemed to have more
10 to talk about... Chit-chatting, instant girlfriends.
11 Perfect. At one point, after dinner, I was alone
12 in the kitchen, drying the dishes, listening to
13 them laugh. And I just...I started to cry. I mean
14 I was so happy, y'know, the two of them, out
15 there laughing like that. After a moment Eileen
16 came in, saw me crying and said, "C'mon Ed,
17 c'mon out, we miss you." I looked at her, bent
18 down, gave her a kiss. This is the girl I want to
19 spend the rest of my life with. I love this girl. My
20 mother came in, saw us there kissing. I looked
21 up at her. She smiled. It was a nice moment, the
22 three of us in the kitchen, quiet. My mother's
23 smile was very different this time, very different
24 than before. Was a wonderful smile, warm, sin-
25 cere, happy. Then I looked over at Eileen, and
26 Eileen was smiling, too.
27
28
29
30
31
32
33
34
35
36

Monologs

for Women

Leslie

Leslie, an unhappy housewife, talks about the eventful daydream she had when she met her husband at the airport.

1 The plane had finally landed. Finally, I was
2 so nervous. I watched through the window as
3 the passengers started exiting the plane. I saw
4 him. He was wearing his tan trenchcoat, as
5 usual, the one with the ripped lining. The one he
6 always wore. As he came closer to the terminal
7 he saw me standing there at the window, hold-
8 ing the baby. Everything was as usual. Another
9 flight, another trip, another day. And as usual,
10 he waved. I waved back. Usual. Usual.

11 *I was glad the baby had finally stopped crying.*
12 *All morning she'd been.... Seemed like an omen. I*
13 *put her back in the carriage, covered her with her*
14 *blanket. She looked content. Good. When I turned*
15 *and looked out the window, he was right outside the*
16 *terminal, coming closer. I started waving. He waved*
17 *back, as usual. Automatic. I stood there like a stone*
18 *pillar with my arm automatically waving. A smile,*
19 *plastered, fake, as usual. Welcoming him home from*
20 *yet another business trip. Not a cloud in the sky.*
21 *Just that big old sun, blazing, and all that blue. I*
22 *was so nervous. He was entering the terminal, walk-*
23 *ing faster. I slowly bent down, took the gun out from*
24 *the basket in the baby carriage. Hid it in my hand.*
25 *Kind of cuffed it, stowed it up my sleeve, my finger*
26 *on the trigger. Ready. He was inside the terminal,*
27 *coming toward us. The airport was crowded. I*

1 *hadn't noticed how crowded it was. So many people.*
2 *He was waving, still waving, coming closer. My*
3 *smile remained locked, as usual.*
4 *"Hi hon, sorry, flight was delayed." A peck on the*
5 *cheek, same place as usual. Then he looked down in*
6 *the carriage.*
7 *"Is that my little girl in there?" Is that daddy's*
8 *little girl?" He kissed the baby, then looked up, saw*
9 *me pointing the gun. Unusual! Highly unusual! His*
10 *look, shock. Shocked! My finger quickly pulled the*
11 *trigger. Three shots and the mold was broken. Shat-*
12 *tered! The apron was off! Three shots, three loud*
13 *shots rang through the airport. One bullet hit him*
14 *in the head. He fell. The wedding cake collapsed.*
15 *Blood on the floor. Screams. I began to walk. Walked*
16 *quickly. People running, hiding, falling to the*
17 *ground. I pushed the carriage as fast as I could. The*
18 *exit straight ahead. A security guard tried to stop*
19 *me. No! No way! I shot him, he fell. People running,*
20 *screaming, hiding! I started to run to the door. Got*
21 *there! Goal! Out! Free! The car, right outside,*
22 *parked, waiting. Put the baby in the front seat, the*
23 *carriage on the floor. Got in, looked in the mirror,*
24 *my mascara was running down my cheek. Joy!*
25 *Tears of...! Started the car, looked over at the baby.*
26 *She was smiling. The baby seemed so happy! As if*
27 *to say, "Yes mom, yes, good!" Broke the mold. The*
28 *apron is off! I put the car in gear. The sky was so*
29 *blue! People were running out from the terminal.*
30 *Never should have married. Never should have mar-*
31 *ried. We drove down the ramp. People still running.*
32 *Sirens. Just not the marrying kind! All that routine!*
33 *That day to day...! I turned on the radio. Soft*
34 *music, soothing. And then, we left, the baby and me,*
35 *drove non-stop, all night, all the way to Mexico.*
36 *(A beat, softer)*

1 　　　Then...he kissed me on the cheek, said, "I'm
2 sorry hon, flight was delayed. Hope you weren't
3 waiting too long."
4 　　　"No. No, not at all. I was just standing here,
5 waiting, thinking about you."
6 　　　He smiled. He was wearing his tan trench-
7 coat with the ripped lining, as usual. We slowly
8 started to leave.
9 　　　"I was just standing here with the baby, look-
10 ing up at the sky. Have you noticed, it's so blue
11 today? And I guess I was just — daydreaming."
12
13
14
15
16
17
18
19
20
21
22
23
24
25
26
27
28
29
30
31
32
33
34
35
36

Bonnie

Bonnie recalls the agonizing moment in the hospital waiting room when the doctor came in with her test results.

1 *(Softly, slightly somber)*

2 I knew. You know. You just.... Maybe it was

3 the look in her eyes. The telltale, hangdog....

4 Maybe it was the way she was walking towards

5 me. *(Softly, to herself)* Who's gonna take care of

6 Kenny? Who's gonna take care of the kids?

7 ...Her slow, deliberate.... The pacing of her

8 steps. Her shoulders stooped, heavy. I don't

9 know, I just knew. I knew what she was about

10 to tell me.

11 She sat down, sat close, right across from me.

12 *(To herself)* What's Kenny going to say? For bet-

13 ter or worse. Better or worse!

14 Doctor Wallen touched my hand.

15 *(Softly, apprehensive)* "Well? What?"

16 "Are you alright, Mrs. Harris?"

17 "Just tell me!" Too loud. Too loud.

18 This shouldn't be happening. Not now. Not

19 now. Damn it! I'm too young! I've got a whole

20 life ahead of me!

21 "Kiss the kids, hon, they're going to school."

22 "Lunch money, Ma! I need lunch money."

23 "Mrs. Harris?"

24 "What are the results?!" Not a question, a

25 demand!

26 I heard three soft bells, then "Paging Doctor

27 Someone. Paging Doctor Something."

1 "Tell me!!" Is that a tear in her eye? Is she
2 about to...?
3 "Negative."
4 "What?"
5 "Your test results were negative, Mrs. Har-
6 ris." *(A softening echo)* "Negative. Negative. Nega-
7 tive. Negative."
8 A soft breeze blowing in the waiting room.
9 "It's just a cyst, a small cyst. It's nothing."
10 "A cyst? Nothing?"
11 "Go home. You're fine. Be happy." Did I say
12 that? Did she?
13 "Ma, what's for supper?"
14 "Go home. You're fine. Be happy."
15 Three soft bells. "Calling Doctor Something.
16 Calling Doctor Someone."
17 I hugged her, hugged her so tight.
18 "Thank you! Thank you, doctor, and the
19 whole medical...! Thank you!"
20 Three soft bells.
21 "I've got to go home, make them dinner."
22 "Calling... Calling..."
23 "I've got to go! They're waiting!"
24 "Calling..."
25 And then...I left.
26
27
28
29
30
31
32
33
34
35
36

Cyndi

*Cyndi, a lonely woman, talks about a man
she had recently met in a bar.*

1 Was four in the morning.
2 Snyder's was closed.
3 Me and Manny was drunk.
4 Streets were quiet,
5 hardly no cars.
6 I said,
7 "C'mon, Manny, let's go."
8 But Manny,
9 Manny got mean.
10 Broke a beer bottle.
11 I said,
12 "Put that down Manny."
13 But he, Manny,
14 said, "No."
15 I said, "C'mon, Manny, let's go.
16 S'go back to my place.
17 Remember, you was there last night?
18 Let's go to my place to crash."
19 But Manny said no. Manny said, "No!"
20 Starts to rain,
21 Rains real hard; pours.
22 Me an' Manny got soaked.
23 "S'go to my place Manny, where it's nice
24 and warm. C'mon, I'll take good care of ya."
25 But Manny put that broken beer bottle up
26 to my face.
27 He had devils in his eyes, they were
28 filled with hate.

1	I knew what he was gonna do,
2	he was gonna cut me.
3	Just like Joe,
4	he was gonna cut my face.
5	Then tomorrow he'll say he's sorry.
6	Tomorrow after they stitch me up,
7	when it's too late.
8	Just like Joe,
9	Manny put that bottle up to my face.
10	We stood there,
11	me and Manny,
12	in the rain, getting soaked.
13	*(A beat)*
14	No man.... No man writes my story.
15	No man pays my way.
16	Was no choice,
17	a dark night,
18	I grabbed that bottle,
19	I cut "his" face.
20	Manny howled, was surprised,
21	cried like a baby.
22	I turned around,
23	walked away,
24	left him there in the rain.
25	He was smart enough not to follow me.
26	Don't even think he knew my name.
27	I left him,
28	bleeding,
29	drunk,
30	crying from the pain.
31	*(A beat)*
32	It was a quiet night.
33	Hardly any cars out.
34	I walked home.
35	Walked home alone,
36	in the dark,

1 by myself.
2 I walked home alone in the rain.
3
4
5
6
7
8
9
10
11
12
13
14
15
16
17
18
19
20
21
22
23
24
25
26
27
28
29
30
31
32
33
34
35
36

Sue

Sue, a college student,
apologizes to her mother for embarrassing
herself on the plane trip home.

1 I don't know. I'm not.... I just.... I don't know
2 what happened, Ma. I.... I knew I was nervous.
3 Coming home, the holidays. One drink, that's all.
4 That's all I was gonna.... Next thing I knew I
5 had two, a second, another. Then a third. And
6 soon the flight attendant.... I was nervous, Ma,
7 very nervous.
8 You gotta understand, my life's.... In Boston,
9 I'm like my own person. I mean for the first time
10 I'm.... I didn't want to come home today. I'm
11 sorry, I didn't. I wanted to stay there, hide
12 under my bed in the dorm in Boston, never
13 leave. And it's not 'cause I don't miss you or
14 Dad, I do. I love you both, you know that. But
15 Ma, for the first time — I'm my own person. And
16 I love it. I love bein' responsible for myself. And
17 I'm doing a good job up there, you should see.
18 But today, today, when I got on that plane, I
19 don't know, it felt like.... I don't know, it was
20 like I was "leaving" home, rather than "going"
21 home. Like I was leaving my "self" back there in
22 Boston. I just.... I don't know, I became like a lit-
23 tle girl again. Your "daughter" got on that plane
24 in Boston. Your "daughter" drank all those
25 drinks, went crazy, ran in the aisles, made a
26 mess. Ma, I'm sorry about the plane, the police.
27 I'll pay you back for the bail, I promise. I'm

1 sorry if I embarrassed you and Dad. I didn't
2 mean to. I don't blame him for not wanting to
3 talk to me.
4 *(A beat)* I better.... I should go up to my room,
5 lie down. I think I'm still drunk. Would you wake
6 me for dinner? Tell.... Tell Dad I'm sorry. No,
7 I'll.... I'll tell him myself, later. *(Looking around, a*
8 *beat, softly)* Tree looks great. It always does,
9 every Christmas. I love the angel you got this
10 year. It's.... It's nice to be home, Ma. Really. I
11 mean it. Really.
12
13
14
15
16
17
18
19
20
21
22
23
24
25
26
27
28
29
30
31
32
33
34
35
36

Martha

While on her honeymoon in India, watching a sunset, Martha's inner monolog to her new husband.

1 *(Softly, relaxed, to herself)*
2 Sunset. Sunset at Jodhpur. The gardens, the
3 mountains. India's so beautiful. Mark looks so
4 calm, so relaxed over there reading his book.
5 He's so handsome in this light. It's perfect; the
6 perfect place for a honeymoon, yes. Mark, you
7 look so content. I'll let you read as long as you
8 like. 'Cause I'm a good wife, I care. You just read
9 your book. *(Looking around)* It's so still here, so
10 quiet.
11 *(A beat, suddenly looking up)* Oh, did you see
12 that? Mark did you see that, that bird?! So big,
13 huge! What was it, a falcon? An eagle? ...Gone.
14 Oh, I should have called to you. You'd have
15 known, you know all those things. You're so
16 smart. Well, hell, s'just a bird. No big deal. You
17 keep reading.
18 *(Looking at the sky)* Um, the sunset is so...!
19 Mark you're missing it. The sky, see how it's
20 changing? The bright, hot, yellow...giving way,
21 softening. Pinks, reds. S'delicious. Mark, you're
22 missing it! I can hardly see you over there; way
23 over there across the table. Mark, you're missing
24 the sunset! It's a once in a lifetime...! Oh go on,
25 read your book.
26 Was that my second or third drink? Well, one
27 more won't matter. I'm allowed. Mark, you won't

1 mind if I order just one more, will you honey?
2 Hell, you won't even notice. So absorbed in that
3 silly book! Where's that waiter? The service here
4 in India is so damn slow. *(Looking over at him)*
5 Mark, I'm getting bored. Bored, Mark! Boring!
6 India is becoming boring! Very.... Very.... Put
7 down that stupid book! I'm talking to you! *(Sud-*
8 *denly looking up)* Oh, look! Look at the sky. Look
9 at that Mark, it's changing again. Pinks, pinks.
10 Soft; forgiving. In an instant all the world is
11 healed. I love you Mark. I'm so glad we got mar-
12 ried. Sky's suddenly so...tender. You have no
13 idea what you're missing, darling. Changing. It's
14 changing.
15 *(A beat)* Do you feel it, the chill? Do you? The
16 sun is starting to dip behind the mountain. Soon
17 it won't be there at all. And all we'll have left is
18 the night. And like last night, we'll have dinner,
19 go back to the room, make love again and then
20 go to sleep. Honeymoon. *(A desperate whisper)*
21 Mark, it's almost over. The sun is going down so
22 fast. Fading fast, disappearing. Almost all gone.
23 Will we be together when we're old? Will we stay
24 married? Will you leave me?
25 *(Suddenly enraged)* PUT THAT DAMNED
26 BOOK DOWN! PUT IT DOWN! I'm here! Here!
27 Over here! Your wife, remember me?! Me!
28 Remember me?! Honeymoon!! Love! For better
29 or...!
30 *(Looking up at the sky, softer, sadly)* Those last
31 few rays peeking out. Trying so hard to stay
32 alive. To hold on. Last rays. Last peek. Glim-
33 mers. Glimmers. Going...Gone...Over. ...End.
34 *(A beat)* Where's that damn waiter?! I want
35 another drink. *(Finishing her drink)* You've left
36 me. *(Smiling)* For another book! You missed it,

1 Mark. You missed the sunset, the beautiful sun-
2 set at Jodhpur. You'll never know now. You'll
3 never know how beautiful it was. What the
4 breeze felt like the moment the sun went down.
5 The sadness, the chill. The moment's gone. I've
6 lost you. Goodbye.
7 *(A beat, suddenly smiling, cheerful, really talking*
8 *to him)* All through? Well, how was the book?
9 ...Hm, sounds interesting. I must read it. You
10 missed a lovely sunset dear. I didn't want to dis-
11 turb you, but it was special. Well, maybe tomor-
12 row. It's getting chilly, think I'll go in. *(Standing*
13 *up)* Why don't you go find the waiter and order
14 us a couple of drinks. *(She starts to leave.)* It's so
15 beautiful here. I'm having such a wonderful
16 time. *(She stops, looks at him.)* God Mark, I love
17 you. *(She smiles, blows him a kiss.)* Bring the
18 drinks in, I'll be waiting. *(She leaves.)*
19
20
21
22
23
24
25
26
27
28
29
30
31
32
33
34
35
36

Jill

*Jill, an abused housewife, shares her fear
and desperation with a newfound friend.*

1 *(A childlike whispered confession)*
2 I want to run away, yeah, but I can't.
3 Trapped, s'like no way out. S'like...living here's
4 like living in a dark room. Dark room with no
5 doors or windows. And he calls me names and...!
6 But I'll tell ya, soon as he's gone, minute he
7 leaves for work — I escape, I'm outta here! Put
8 something nice on, get dressed, go downstairs,
9 across the street to the bar, see... a friendly face,
10 like yours. You got nice skin, pretty eyes, you
11 know that? Eyes that say, "Yes." You gotta nice
12 smile.
13 And then we come back...
14 *(She looks around, joyful.)*
15 And then this room — has doors! Big, open
16 doors! And I can breathe for a while, there's
17 windows! The light changes; s'brighter, much
18 brighter! 'Cause now I'm with my friend, my best
19 friend. And he, he don't exist! He...! S'just me
20 and my girlfriend having fun, hanging out.
21 *(A beat, smiling)*
22 Can I get you some coffee or something, huh?
23 Jeez, my name's Jill, I didn't tell you, did I?
24 Guess I forgot. Jill. Jill.
25 ...What's yours?
26
27
28

Connie

Connie, a young, overprotective mother tells her husband Cy about an upsetting incident that happened with their son that morning.

1 He said that, that's what he said. This morn-
2 ing when I gave him his bath. Stood up in the
3 tub, put his hand on my shoulder and said, "Ma,
4 I want to be a rabbi." A rabbi, could you bust?!
5 At first, first, I thought he said, "a rabbit." *(Smil-*
6 *ing)* Yeah, thought he said, "I want to be a rab-
7 bit, Ma." Almost dropped the sponge I laughed
8 so hard. I mean can you imagine? But then he
9 looked at me, seemed so serious suddenly. You
10 know those eyes of his. Said it again, loud and
11 clear, black and white. Looked like a little
12 Moses in the tub waiting for the waters to part.
13 *(Slowly, serious, very strong)* "Ma, I want to be a
14 rabbi, a rabbi, you understand?!" I stopped,
15 smiled, what could I...? Said, "OK, sure honey, if
16 that's what you want." Washed the soap off,
17 towel dried him, baby powder, kissed him on the
18 head and gave him a big hug. Well, he gave me
19 a look, seemed upset, started to cry. I didn't
20 know why. I asked him, "What's wrong? What's
21 the matter, Marty?" Wouldn't answer. Stood
22 there like a stone. Looked at me like I was the
23 worst mother in the world; like I'd just stabbed
24 him in the heart! "What, Marty?! Tell me." Then
25 he ran to his room, slammed the door, locked it
26 shut. Wouldn't let me in. Couldn't get him out.
27 Been in there all morning. All-morning-long! I've

1 been sitting here, waiting for you to get up.
2 We've got a problem, Cy. Marty, your son. He
3 won't come out. S'locked in there. What are we
4 gonna do? What are you gonna do, Cy?
5
6
7
8
9
10
11
12
13
14
15
16
17
18
19
20
21
22
23
24
25
26
27
28
29
30
31
32
33
34
35
36

Joan Francis

*Joan Francis realizes how she really feels
when she decides which movie and movie star
she'd like to see and be.*

1 *(Softly, playful, romantic)*

2 I'm.... I'm in the mood for a Julia Roberts

3 movie, yeah. Something light, uplifting, a

4 romance; a romantic comedy, yes. Buy myself a

5 big bag of popcorn, Diet Coke™, sink into my

6 seat and watch Julia flirt, play, giggle, be sexy.

7 Go girl!

8 I want to be just like Julia, yeah. Pout my

9 thick lips, smile shyly, always get the guy,

10 always. But when he first makes his move,

11 y'know, early in the movie, I'll be coy. I'll say,

12 "I'm sorry, I'm just not interested!" Push my

13 thick hair back, put down my drink, sashay

14 right out of there. Feel all the eyes of all the men

15 in the bar, staring, drooling at my thin, sexy

16 body. And he'll come running after me, my

17 hunk, my leading man. And I'll pretend I don't

18 want to be bothered when he stops me on the

19 street and begs for my attention. "Will you just

20 leave me alone?! I'm not interested mister, real-

21 ly!" I mean I'm Julia Roberts, I can say whatev-

22 er I want, however I want to say it. Nobody'd

23 ever think I was mean, no, just "adorably defi-

24 ant." And for the rest of the movie, and I'd make

25 him prove his love, put him through hoops of

26 fire. *(Becoming desperate)* I mean I'm Julia

27 Roberts, and the public is paying millions to see

1 me! If I...if I don't somehow keep his interest,
2 the public would stop caring. I've got to keep
3 him interested somehow or they'd find somebody
4 else, replace me. I can be tossed aside, thrown
5 away like yesterday's starlet! Well you know how
6 fickle Hollywood is! And he'll find somebody
7 else, my leading man. You know how fickle men
8 are! He'd dump me, reject me! Then what kind
9 of movie would we have, huh?! Not a Julia
10 Roberts movie, not a romantic comedy. There's
11 nothing funny about rejection! Nothing funny at
12 all! It wouldn't be a Julia...! Be too sad, too life-
13 like, too real! *(Angrily)* You don't dump Julia!
14 People wouldn't stand for it! I know I wouldn't!
15 *(She composes herself.)* What the hell am I talk-
16 ing about here? Hey, I'm not in the mood for a
17 Julia Roberts movie. No, not at all. Where's the
18 paper? Julia's too much of a wimp, a pushover.
19 Where's that damn newspaper?! Julia's a victim.
20 Been there, done that! I want to see someone
21 who has more oomph! I'd like.... I think.... *(Sud-*
22 *denly, a devilish smile)* Yeah. Yeah, I'm in the
23 mood for a Sigourney Weaver movie. A good old
24 fashioned chin slugging, alien bashing, groin
25 kicking Sigourney Weaver movie! Yeah. Yes!
26 Sigourney Weaver, a woman with power, who
27 doesn't take any guff. Go girl! I'm going to a
28 Sigourney Weaver movie right now, and don't
29 you try and stop me!
30
31
32
33
34
35
36

Eloise

Eloise, a mentally disturbed, (perhaps) very wealthy woman, tells her husband about her very bizarre day.

1 *(Rambling)*
2 Where was I? Oh yes, this morning, when I
3 got up. Well, after I cat-napped; hardly ever
4 sleep any more, you know that. Anyway, last
5 night, someone drugged me — again. One of the
6 servants, I'm sure. Put something in the pot
7 roast, I believe. Where was I? Oh right, you were
8 sleeping, sound asleep. Your head was lying
9 comfortably on the pillow, your eyes closed. So
10 I assumed,... But with me dear, please, never
11 assume I'm sleeping just because my eyes are
12 closed. Always check my pulse, see if I'm breath-
13 ing. Where was I? Oh yes. *(Smiling)* I love you. I
14 love you very much. Do you know that? You
15 know that, don't you? So this morning when I
16 woke up, I noticed it was snowing. Yes, snow
17 everywhere. There were sirens going off in my
18 head, my eyes were burning, and this room
19 seemed like a three ring circus. But it was all
20 OK because it was snowing outside. Little white
21 flakes. The servants were scurrying around,
22 opening curtains, letting the damn daylight in.
23 Every one of their movements meant to annoy
24 me. Every gesture, too big. Every smile, a lie.
25 Betrayal and deceit everywhere. Camouflage.
26 Dangerous. *(Whispering)* We really must move. We
27 must leave this house soon. Every corner's got

1 an angle. Every fisherman's got a hook. And this
2 pond's getting smaller, dear. This house just isn't
3 big enough anymore. Where was...? Someone
4 brought me my breakfast tray. I was, of course,
5 polite, courteous. Mistress of the manor, take the
6 high road. Never let them see you sweat. But
7 *they* sweat all the time. The smell! Rotten. When
8 they bend down to place the tray.... Their odor!
9 Speak to them. Recommend deodorant. There's
10 no need to smell like that. Where was I? Oh yes,
11 snow, was snowing out, a blizzard. I wanted to
12 wake you. But you looked.... I tip-toed down-
13 stairs, opened the front door, all the way. All the
14 way, wide open! Stood there in the doorway,
15 feeling the warm summer breeze. The smell of
16 fresh-cut flowers from over in the park. Could
17 you turn on the light, please? It's getting dark
18 out. Thank you. Then I bent down, right there in
19 the doorway, gently touched the snow. It was so
20 cold, wet. Made us a big old-fashioned snowball.
21 Round, hard. Packed it tight like a tough little
22 kid. Stood there, tossing it from one hand to
23 another. Oh I wanted to wake you, share the
24 moment! The feeling of the cold and warm. Felt
25 so good! Everything felt so good again! For the
26 first time in...! But just knowing you were here,
27 upstairs in our bed.... And that soon I'd come up
28 here, wake you, get my morning kiss. Join you
29 for a second breakfast. Place my snowball next
30 to the rose on your breakfast tray. A gift from
31 me to you celebrating the beginning of another
32 day. Another wonderful day. Could you turn the
33 light on? Could you turn the light on, please? I
34 hate the winter. So dark, so early. *(Smiling)*
35 Thank you. That's better. That's much, much
36 better. What would I do without you?

Meredith

Meredith furiously rages on about the problems of old people, and how they affect young people.

1 (*An angry tirade*)

2 I hate 'em, that's all, I just hate 'em! Way they
3 walk, limp, bump into things; bump into me.
4 Never say they're sorry, no, too preoccupied
5 with their own thoughts. And did you ever smell
6 their breath? P.U.! Put those teeth back in,
7 please! And they're always in a bad mood,
8 always. Haven't you noticed? Constantly com-
9 plaining about this or that; everything. The
10 world outside, their bed, their bones, their joints.
11 How everything hurts! They're just one big pain,
12 old people.
13 And they can't sleep, no! Up all night so
14 they're tired all the time. Can't eat, digest their
15 food, go to the toilet. Constantly constipated.
16 Have to eat barrels and barrels of prunes. I will
17 never get that old, never! Not like that. I won't
18 let that happen to me!
19 And all they ever talk about, all they "ever"
20 talk about is the past. The glorious past, the way
21 it was, the damned good old days. Always back-
22 tracking, back in time. And no matter how hard
23 you try, you can't....
24 He falls, breaks a hip, so "you" have to take
25 care of him. Give him his meals, find him his
26 pills; his many, many bottles of pills. Which one,
27 which time of day? Make sure he swallows,
28 doesn't choke!

1 And then you watch, watch him as he slowly
2 gives up, starts to fade. A little more today than
3 yesterday. You can see it in his eyes. You're los-
4 ing him, he's going. You tell him a joke, a story,
5 anything. But he's stopped recognizing. Didn't
6 know.... Didn't even know who I....

7 Grandpa was so robust, remember? So alive,
8 full of life! Always smiling. Strong, firm hands.
9 Would throw us up in the air and catch us,
10 remember? He took me to my first movie, did
11 you know that? Yeah, *Heidi. Heidi.* And I fell
12 asleep in his lap and.... So safe.... He was
13 always....

14 Grandpa got so old. So...decrepit. Why
15 couldn't...? How dare he...?! Why couldn't he
16 just...?

17 *(A beat. Softly)*

18 I remember.... Do you remember how he...?
19 That look he'd ...? The way he.... I'll always
20 remember.... He was so...! He was.... He...was.

21
22
23
24
25
26
27
28
29
30
31
32
33
34
35
36

Ceil

Ceil, an unhappily married woman,
tells about her most unusual afternoon
with a man she met in a bar.

1 *(Softly)*
2 I went for a walk. Just a few blocks, Times
3 Square. Felt I needed to.... Sometimes I go over
4 there just to get out of the house, y'know, clear
5 my head. Was thinking.... Oh I don't know what
6 I was thinking, just went, walked. Looking at all
7 the people. Y'know, s'a matinee day, crowds,
8 tourists. Was nearly lunchtime so I figured I'd
9 get something, a bite to eat. Wasn't really...
10 Stopped off somewhere, a bar on Eighth Avenue.
11 But I didn't eat, wasn't hungry, had a drink. Was
12 sitting at the bar there and this man sat next to
13 me, next stool. Smiled, said hello. We talked. He
14 seemed very nice. Said his name was Hank. Was
15 in his early thirties, I guess. Attractive, very
16 attentive. Looked right in my eyes. Told me...
17 told me how pretty I was. I smiled, wanted to
18 say, "C'mon mister, who are you kidding?" But I
19 sat there, ate it up. Let him go on. Watched him
20 looking at me. All that attention, y'know? Felt so
21 good. S'been.... S'like it was just the two of us
22 sitting there, no one else in the whole... Had a
23 couple more drinks, talked some more. And soon
24 he seemed...I don't know, "desirable." Asked
25 myself, "What-are-you-thinking?! Are you crazy,
26 out of your mind?! What the hell are you doing
27 here, middle of the day, a bar, strange man?!

1 Milt would...! You're married! Married, have you
2 forgotten!! Are you crazy?!" Then...then, I invit-
3 ed him back. Said I was.... Told him right out I
4 was interested, lived a few blocks away. Told
5 him that I was married, that my husband was at
6 work. But if he wanted to come back.... Made no
7 bones about it. He smiled, got up, we left.
8 *(Building in excitement)*
9 We walked — fast! The blocks between here
10 and there just flew by. Hardly talked, maybe a
11 word or two. Passing people very fast. Rushing!
12 The danger — excitement! Mean I didn't know
13 who he was, knew nothing about him! Got to the
14 building, quickly opened the downstairs door,
15 rushed in, up the stairs, key in, opened the door,
16 and...and inside, standing there — was Milt. He
17 was home, had come home early. He looked at
18 us. I tried to smile. Hank...just...froze.
19
20
21
22
23
24
25
26
27
28
29
30
31
32
33
34
35
36

Fran

Fran tenderly recalls telling her daughter her favorite story when she was sick.

1　　*(Reciting)*
2　　"...But as she puffed down the mountain, the
3　　Little Blue Engine seemed to say... 'I thought I
4　　could. I thought I...' " *
5　　*(She stops herself, smiles.)*
6　　Must have told her that story, I don't know,
7　　maybe a hundred times. Measles, mumps, when-
8　　ever she was sick. "Tell me *Little Engine That*
9　　*Could!,*" she'd say. "Little Engine, Mommy! Little
10　　Engine!?" Finally, I just memorized it. I'd get
11　　under the covers with her, and she'd hold me,
12　　eyes wide, listening, every word; like she'd never
13　　heard it before. Like it was for the first time. Tell
14　　me, Mommy, Little Engine, tell me! And so I'd
15　　tell it to her, once again. And, as always, at the
16　　end, I'd look over, and she'd be sound asleep.
17　　Amazing. The perfect medicine. The perfect
18　　story, so hopeful, full of hope. She'd be sound
19　　asleep. Dreamland. And when she woke up, she
20　　always felt better. Always.
21
22
23
24
25
26

* from THE LITTLE ENGINE THAT COULD by Watty Piper ©1976 by Platt and Munk, Publishers

Lenore

Lenore recalls a painful childhood Christmas memory.

1 Was just another one of her stories, I thought.
2 Little Miss Make Believe. She'd be up there in
3 her room making up new ones all the time.
4 Crazy, ridiculous stories. When she told me that
5 one, I told her to get away. Said, "You tell
6 Momma that story, you'll be sorry, you'll see.
7 Momma'll throw you out. Should be ashamed of
8 yourself! I don't wanna be your sister anymore!"
9 She cried, went back up to her room, closed the
10 door. Never mentioned it again.
11 Was a couple of months later, Christmas time.
12 How we loved celebrating Christmas in our
13 house! It was a real big deal. Me and Momma
14 had just gotten back from doing some last
15 minute shopping. We were laughing so hard,
16 having so much fun. Our arms were filled with
17 stuff, Christmas gifts for Liza and Poppa.
18 Momma whispered, "C'mon, hurry up, let's hide
19 these things in the kitchen 'fore your father
20 wakes up." So we quickly tip-toed to the kitchen,
21 turned the light on. Now when the light was on
22 in the kitchen it was very well lit. It was by far
23 the brightest room in the house. When Momma
24 turned the light on they were there, Liza and
25 Poppa. They were lying on the linoleum floor.
26 Liza looked like she'd been crying. Poppa
27 jumped up. He quickly started getting dressed.
28 He was yellin' something, I don't remember

1 what. I looked over at Momma. She was
2 stunned. Was like a tornado had suddenly hit
3 our house. And even though everything was in
4 its proper place — it was total disarray. Poppa
5 was saying things but wasn't making any sense.
6 Liza slowly buttoned her blouse, looked away.
7 Momma just stood there in the doorway, staring
8 at them. Then she dropped the gifts, turned off
9 the kitchen light, leaving Liza and Poppa stand-
10 ing there in the dark. I followed Momma into the
11 living room. We sat on the couch. I told her that
12 Liza had tried telling me but.... Momma said,
13 "Not another word!" She turned the T.V. on,
14 turned the volume up loud, very loud. We sat
15 there, silently watching.
16 Later that night, Poppa packed up and left.
17 Momma didn't even let him say goodbye to us.
18 We never saw him again. Momma got a job in
19 town. And we all just, I don't know, went on liv-
20 ing, got older. And Christmas in our house, well,
21 it was never the same again.
22
23
24
25
26
27
28
29
30
31
32
33
34
35
36

Mimi

*Mimi, a young mother, who grew up
in orphanages and foster homes
talks about a very special moment with her
husband and their new baby.*

1 *(Softly, a gentle memory)*

2 It was like a scene from a dream; a thought
3 I'd had a thousand times in the homes, the many
4 foster homes I had grown up in. It was like a
5 memory of a memory, a wish, a hope, a prayer.

6 I was standing there, by the window, in the
7 dark, breastfeeding the baby. The door opened
8 and he walked into the room, smiled, watched. I
9 turned to him and said, "What?...what?"

10 He said, "Nothing, nothing at all." Then he
11 came over, put his arms around me, looked
12 down at the baby, gave her a gentle kiss on the
13 cheek. Warm. Perfect. Just as I remembered.

14 The storm had finally stopped, the stars were
15 bright. It was nearly two in the morning. We
16 stood there in our pajamas, in front of the win-
17 dow watching the last of the snow fall. Quiet.
18 Then I looked at him, smiled. He said,
19 "What?...what?"

20 I said, "Nothing, nothing at all."

21 The room was just as I had remembered. The
22 moment, perfect. It was like a scene from a
23 dream; a thought I'd had a thousand times.

24

25

26

Ginny

*After one too many indiscretions, Ginny tells
her unfaithful husband off.*

1 *(In a rage)*
2 Just leave! Go! Go to your movie! Lose your-
3 self! Go ahead, lose yourself John, in the dark in
4 the movie with Julia Roberts! Isn't that where
5 you're going — to the movies? Go ahead, let
6 yourself go — all the way. All the way John, just
7 you and Julia! Enjoy the show. And then after,
8 after you're through, when you come crawling
9 back here, to tell me about it, I'll be up. I'll wait,
10 just like always. Like I've always waited. Listen
11 to every-little-detail. *(A sudden edge)* The good lit-
12 tle woman, huh?! The good little wife! And you
13 can tell me all about it, Tom. About Julia or...
14 Every nook and cranny. Get it off your chest.
15 Confess. Tell me till it echoes off the walls here.
16 Till I finally have to put my hands over my ears,
17 beg you, please, stop talking! Don't tell me, I
18 don't want to know! I never did! Go to your
19 movie. Go ahead. But when you come crawling
20 back tonight there might be a plot twist. There
21 may be a surprise ending in the final reel. Just
22 have to wait and see, Tom. So go, say hi to Julia.
23 Say hi, Tom, and give her my very best!
24
25
26
27
28

Donna Jean

Donna Jean tries to say good-bye to her boyfriend but ends up painfully rambling.

1 What am I trying to say? I don't know... I
2 have no i.... I'll just get a job I guess. Factory,
3 like everyone else here. Can you imagine me an'
4 Momma workin' in the same place? Livin' with
5 her and then working together? I'll definitely
6 have to move out, get a place of my own. Those
7 damn diplomas don't mean anything, huh?
8 JOKE! But you were no fool, never wasted your
9 time in school. Me and Momma workin' togeth-
10 er, can you imagine? I'll probably end up in
11 some psycho ward at Dellclare State, my hands
12 tied together in a straightjacket, staring up at
13 some ceiling, swearing it's the Sistine Chapel or
14 something. If you want, you can come visit me
15 there on weekends. I'll be the one who thinks
16 she's a giant lemon popsicle. What am I saying?
17 You don't have to come. It's a long ride from the
18 city. God, I hate you! Just go, catch your bus!
19 Don't call me, don't you dare. Clean break, no
20 letters. Nothing! I don't want to know how or
21 what you're doing down there. What are you
22 staring at? No last minute memories, please. Just
23 GO! It's probably pretty obvious, I'm making a
24 total fool of myself here. I *am* indeed a giant
25 lemon popsicle! And I probably will end up at
26 Dellclare State, sooner or later. Now just go! I'm
27 running out of words here. This car feels like it's
28 filling with steam. S'getting very, very warm.

1 Damn you, get out! My buttons are bursting, I'm
2 running out of breath! I'm starting to melt! Be
3 melted lemon popsicle all over the front seat.
4 Who'll be here to help me clean it up? Not you.
5 Not you! *(A beat, softer)* I'll miss you. Please don't
6 leave. OK, I've said it, humiliated myself. What
7 are you staring at? Haven't you ever seen a pop-
8 sicle make a fool of herself before? Write to me,
9 huh? Call me. Let me know how you're doing.
10 Have a good trip...I love you, I do.
11
12
13
14
15
16
17
18
19
20
21
22
23
24
25
26
27
28
29
30
31
32
33
34
35
36

Liz

After leaving the scene of an accident,
Liz furiously lambastes her companion,
the drunken driver who was at fault.

1 No! No, it was not! It was *not* an accident! I
2 was there just now, remember? Me?! Next seat?!
3 Woman who almost went through the wind-
4 shield!
5 Just had to have it, huh? That last drink?!
6 Even after I said, "C'mon, John, I think that's
7 enough!"
8 And then, in the car, when I kept yelling,
9 "Slow down! Slow down, John, you're going too
10 fast!" You just kept going. "Too fast, John."
11 Then leaving it there like that. Just... Alone,
12 injured, howling! It was howling, I heard it! And
13 all you could say was, "I didn't see it, I couldn't
14 stop, I didn't hear it!" Didn't see?! Couldn't stop?!
15 Didn't hear?! Where the hell'd you get your
16 damned license?! HIT AND RUN, John! Was a
17 hit and run. And now that poor thing's out there
18 dead, cars running over it in the rain. And you
19 killed it, John! You, John, you're responsible.
20 And either you go back there with me right now,
21 or I'll go myself. Well, what's it gonna be, mur-
22 derer?! ...Well coward, you coming?! Are you
23 coming John, or not?!
24
25
26
27

Gwynn

Gwynn, a single mother, talks about how she escapes every day from the rigors and tensions of her life at home with her children.

1 *(Tensely)*
2 Chewing gum.
3 Blowing smoke.
4 Breakfast for the kids.
5 Taut and tense.
6 "Put that down!"
7 "Where's my cigarettes?!"
8 Wired,
9 tired.
10 "Did you hear me?!
11 "Leave your sister alone!"
12 "Somebody get that."
13 "Somebody get that!"
14 "SOMEBODY GET THE PHONE!!"
15 *(A beat, soft and slow)*
16 An omelet.
17 An omelet fell from the skillet to the floor.
18 That's all it took,
19 I stop and stare.
20 Then go directly
21 to the front door.
22 "Where ya goin', Mom?"
23 "Be right back,
24 just going to the store."
25 Hat and coat,
26 pocketbook.
27 The man on the corner;

1 the man knows me.
2 He knows what I'm looking for.
3 "To ease my day."
4 "To find your way."
5 The man on the corner says,
6 "Score?"
7 "Why else would I be here?"
8 I say tensely.
9 "So soon?" he says.
10 "Please, just...
11 I'd like some more."
12 I blow smoke,
13 chew gum,
14 say,
15 "Here's your money, I gotta run."
16 A quick exchange.
17 "Here's your change."
18 The man on the corner smiles,
19 "Scored."
20 Then down in the basement,
21 three floors below mine.
22 A light from a spark starts the flame.
23 Enter Mr. Magic,
24 dressed in white powder,
25 driving his car through my veins.
26 A roll of my head.
27 And I fall,
28 fall,
29 into a funny, soft
30 featherbed.
31 Giggle and laugh,
32 roll on my side.
33 Warm bubbles float over me.
34 I'm covered
35 in a warm, bubbly tide.
36 But then,

1	a terrible thought.
2	A stranger telling my kids,
3	"Sorry, your mamma just died."
4	I sit up,
5	sweating,
6	terrified.
7	The featherbed disappears.
8	I'm crying,
9	soaking wet.
10	My face is covered with tears.
11	I have to make breakfast.
12	They're waiting.
13	The kids are alone
14	upstairs.
15	Put the powder in my purse,
16	leave,
17	start to curse.
18	Return home,
19	the omelet's still on the floor.
20	Right back where I was.
21	I hug my kids,
22	"Where were you, Momma?
23	You said you were going to the store."
24	"It was closed,"
25	I say.
26	"Have you eaten yet?
27	Does anybody want some more?"
28	I'm a happy momma now,
29	buzzing through breakfast.
30	Happy for a few hours
31	score.
32	I hug my kids,
33	we play with toys,
34	My life at home's
35	no longer a chore.
36	But that constant reminder.

1	Outside my window.
2	Outside my door.
3	The man on the corner,
4	waiting.
5	Maybe after lunch.
6	Or maybe after dinner.
7	A little later,
8	a little more.
9	
10	
11	
12	
13	
14	
15	
16	
17	
18	
19	
20	
21	
22	
23	
24	
25	
26	
27	
28	
29	
30	
31	
32	
33	
34	
35	
36	

Giselle

*Giselle recounts an upsetting hospital
visit to a man she met in a bar.*

1 I stood there, started talking, saying things.
2 Words. I don't know, anything. Anything that...
3 Finally, I just told him I was sorry. Sorry, can
4 you imagine? Sorry, now, as if... I looked at his
5 face, for some sign. But his eyes — nothing. He
6 had no idea. Eyes that only reflected, that didn't
7 respond. Very different from the eyes in the bar.
8 I looked over at his mother, sitting in the chair
9 by the bed. She was staring, just staring at me.
10 I looked over at his brother, standing by the
11 window.
12 "He insisted that I drive," I told them. "We
13 just met. He knew how many drinks I'd... He
14 insisted!"
15 His mother looked away. His brother softly
16 said, "I think you'd better leave, miss."
17 "I didn't want to drive! I told him we should
18 call a cab!"
19 His mother said, "Enough! Please-leave-now!"
20 The nurse took my hand, started moving me
21 towards the door.
22 "Just family, for now," she said softly. "Just
23 family, OK?"
24 "I'll come back tomorrow," I told them.
25 "Maybe tomorrow he'll feel...."
26 "Just get out!" his brother yelled.
27 "It wasn't my fault!" I tried telling them. "It
28 wasn't!"

1 "Out! Now!" His brother yelled, kept yelling.
2 "Out!"
3 Suddenly some interns and orderlies came
4 running in to see what all the commotion was
5 about. The nurse pushed me through the crowd,
6 out the door, into the hallway.
7 Outside the door she held my hand, tried
8 calming me down. I was trembling. We stood
9 there for I don't know how long.
10 "Look, you should be lucky you're alive," she
11 whispered.
12 "Lucky?" I thought.
13 "That was a terrible accident, the car was
14 totaled. He may never come out of that coma."
15 The lights in the hallway were white, bright,
16 unforgiving.
17 "I didn't want to drive."
18 "But you did, miss. You drove."
19 "He insisted!"
20 "Go home," she said.
21 I looked at her.
22 "And say a prayer for him."
23 I turned, started to leave, was still trembling.
24 I left my car in the parking lot, took a taxi, and
25 went home.
26
27
28
29
30
31
32
33
34
35
36

Lucille

Lucille recalls the happy and tragic experience of living on a farm during her childhood.

1 Ever been upstate, near Lenom? That's where
2 I'm from. S'beautiful up there. Farm country.
3 Nice place to grow up. Good place to raise a
4 family.
5 Well, we had a well on our farm in Lenom. A
6 wonderful old well. Sure, we had plumbing in
7 the house, but we also had this well in our back-
8 yard. My father love to drink from it. Reminded
9 him of his childhood, I guess, simpler times.
10 He'd get up every morning, go outside, fill a
11 glass from the well, and toast to the new day.
12 Even in winter, when the water in the well was-
13 n't frozen, out he'd go. I remember watching him
14 from my window, one of my favorite childhood
15 memories; seeing him lift his glass, big smile,
16 then a toast to the early morning sun. His little
17 ritual, every day.
18 Well one morning he woke up and didn't go
19 to the well. He was ill, couldn't get out of bed.
20 You have to understand, my father never got
21 sick.
22 There was a factory nearby. Right down the
23 road. And it seems, well we found out, that they
24 were illegally dumping chemicals in a river that
25 connected somehow with our well. Catch on?
26 You with me? See where I'm going? Long story
27 short, my father got sick, very sick. Cancers.
28 Horrible sores all over. And me and my mother,

1 couldn't do a thing. We just watched him, dying,
2 day after day, doctor after doctor. I was just a
3 little girl, didn't understand. I still don't.
4 My mother tried suing the company, but they
5 had a lot of money, good lawyers. We lost the
6 farm, had to move to the city. Long time ago. But
7 not the end of the story. I never gave up the
8 fight. I became a lawyer, and now, finally, after
9 all these years, we won. The factory's been
10 closed. And tomorrow I'm moving back to our
11 farm in Lenom. Bought it with some of the
12 money we won. Moving back with my husband,
13 daughter, and two sons. And the first thing I'm
14 going to do, yeah, you guessed it, is uncover and
15 clean out that well. Fresh water, clean water,
16 good. And hopefully, one day soon we'll all
17 drink from that well. And just like my father, I
18 plan on getting up every morning and toasting
19 to the early morning sun.
20
21
22
23
24
25
26
27
28
29
30
31
32
33
34
35
36

Marge

After being stalked one time too often by her former, abusive boyfriend, Marge finally tells him off.

1 (*In a rage*)
2 Alright you looked, you found me, now leave!
3 Did you hear me?! Out! Now!
4 Why's it gotta be this way? Huh? Why?! Don't
5 you have any pride?! You're not happy till it gets
6 ugly, are you? Till I have to scream, yell, call the
7 cops. Look, I know what you want. Forget about
8 it. We're through! Been there, done that!
9 Let me tell you something, the only thing I
10 feel when I look into your bloodshot, little eyes
11 is a passionate regret! I regret ever knowing
12 you! And the only memories I'll remember are
13 those polyester promises you never kept! Mis-
14 takes, bygones! We're through, understand?!
15 UNDERSTAND?! And I swear if you keep com-
16 ing back here bothering me, I'll personally see to
17 it that your little head is put through a razor-
18 sharp meat grinder. And you know I know just
19 the boys who'll do it. And I will stand there
20 baby, and I will stand there, watching your lit-
21 tle head shred. And me — *I* will personally be
22 the one pushing down on the damn meat grinder
23 switch!
24
25
26
27

Sarah

Sarah recalls the intense relationship between her husband and son.

1 He loved to swim, always. Loved the water
2 since he was a little boy. You have no idea. Both
3 Harry and his dad, the two of them. Harry was
4 just a baby. His father took him down to the
5 water. Lake's right down there, down the hill,
6 see? That's where it all started. Twenty some-
7 thing years ago, that lake. He must have been
8 what, two years old then? You'd think he dis-
9 covered God. Couldn't get him out of that water
10 once Sam put him in. Just dropped him in the
11 water, dared him to swim. Can you imagine?
12 Dared him, a two year old. And he did. Harry
13 defiantly began to swim! Like magic. That's how
14 it began. And then each day thereafter, the two
15 of them would get up, get dressed, race down,
16 jump in, swim. Race each other; compete. I per-
17 sonally thought they were both nuts getting up
18 that early just to swim. And then years later,
19 that first time when Harry beat his father swim-
20 ming, monumental event. Harry was about eight
21 or nine then. Sam was definitely not happy.
22 Took it a little too personally. I mean you'd
23 think he'd be happy about his son.... Then, every
24 day after that, I always knew who won. Could
25 see it in their faces. I also knew who lost. Their
26 competitiveness, their rivalry got worse as the
27 years went on. I mean it wasn't just a little
28 morning contest for fun anymore. Was a ritual,

1 a bloodthirsty sport. Was horrible here in the
2 mornings, I'm not kidding. This house became a
3 war zone. And whoever won would torment, *tor-*
4 *ment* the loser. Brutal. Insane. Ridiculous. And
5 Sam was still just a boy, mind you. I tried talk-
6 ing to them, telling them how crazy... "None of
7 your business!" they'd say. "Fine," I'd say. "Kill
8 yourselves, see if I care!" It made me nuts. I
9 couldn't bear to be here in the mornings. So I'd
10 leave, drive into town, have breakfast at the
11 diner. Stay there till they were finished with
12 their swim. Then return in the afternoon.
13 Harry was about sixteen then. I'd just fin-
14 ished having breakfast. Carl, our neighbor, came
15 over to my table at the diner, told me. He didn't
16 have to say a word, I knew. Sam was dead. Carl
17 said they thought it was a heart attack. That he
18 had died during their swim. Heart attack, then
19 drowned. I went home. I looked after Harry. He
20 cried.
21 I'll tell you no one cried more than Harry did
22 at that funeral. I've never seen anyone cry like
23 that before or since.
24 *(A beat)*
25 He still goes down to the water every morn-
26 ing when it's warm, same as usual. Sits there
27 awhile, looks out. I watch him from up here
28 sometimes. I know what he's thinking. I know
29 exactly.... Then he goes in for his swim, his
30 morning swim. Swims faster each morning.
31 Always faster! Faster! Got to beat the previous
32 day's record.
33 State champion, huh? Yeah, he's a winner.
34 S'got a room full of trophies, you know that?
35 He's very competitive, my son, just like his
36 father was. He swims with a vengeance, they

1 say. It's true. That's all he lives for, those
2 awards, the recognition.
3 *(Smiling)* I never saw a boy who loved his
4 father more. And the water, he loves the water,
5 always did. Ever since that first time his father
6 took him down there. And they splashed and
7 splashed, and then *(She stops smiling.)* ...his
8 father — taught him how to swim.
9
10
11
12
13
14
15
16
17
18
19
20
21
22
23
24
25
26
27
28
29
30
31
32
33
34
35
36

Diedre

Diedre, a delusioned woman, tells about the terrifying day that she's just imagined.

1 *Afraid? Me? No, I'm not afraid of anyone. I am*
2 *the bravest soul you've ever seen. Nothing terrifies*
3 *me, nothing!*
4 *Why just this evening, early this evening, this*
5 *man on the street, stopped me, grabbed me, blocked*
6 *my way. He was going to rob me, this man. Yes, that*
7 *was his intention, clearly. He had a knife, wore a*
8 *mask. But I didn't scream. No, not me, no sir. I*
9 *stood there. Didn't cry, didn't panic, nothing. Brave.*
10 *Then one quick kick, that's all it took. One quick*
11 *kick and I brought him to his knees. One quick kick*
12 *and the devil got his due. The roles were reversed,*
13 *and this crook was on his knees. And his knife was*
14 *in my hands, and he was pleading, begging for his*
15 *life. Yeah, sure, I could have just walked away.*
16 *Could have, yes. I could have just left him there,*
17 *called the police. But I didn't, no. I couldn't. You*
18 *know what I did? (Smiling) I cut his throat from ear*
19 *to ear. Yes. Stood there, watching him bleed. Waited,*
20 *I waited, until finally he gagged on his own blood,*
21 *then he fell to the ground and collapsed. He was*
22 *dead. The devil got his due. It was late, I had to*
23 *leave, so I left him. I was on my way to the super-*
24 *market, food shopping.*
25 *When I got there it was almost closing time. But*
26 *they let me in anyway. They're so nice at that store.*
27 *I zoomed through the aisles with my cart, plopping*
28 *this in, plopping that. Tossing canned goods, pasta,*

1 *lemon meringue pie. But by the time I got to the*
2 *frozen foods my cart was filled to the brim. A help-*
3 *ful clerk standing there offered me his assistance.*
4 *But I told him I didn't need any. "Thank you, I'm*
5 *fine."*
6 *"They have unannounced specials," he said,*
7 *"unbelievable bargains, right this way." Before I*
8 *could say no, he grabbed my cart, pulled me into the*
9 *stock room. Now there were no specials in there, no,*
10 *nothing was on sale. There was nothing inside that*
11 *dimly lit room but empty boxes. He lied to me, that*
12 *clerk. Then he lunged at me, tore off my coat, ripped*
13 *at my new blue blouse, pushing me to the ground.*
14 *"Bad manners!" I said, "Bad manners! I should*
15 *report you to the manager right now!" Then he*
16 *grabbed at me again, tried pulling me down. That*
17 *was it, I was angry. I was furious! I yanked myself*
18 *free, got to my loaded cart. And you know what I*
19 *did, know what I did then? I zoomed into him as*
20 *fast as I could, again and again. Yes! Again and*
21 *again! Teach him a lesson. I rolled over him, jam-*
22 *ming him against the wall. Until finally his eyes*
23 *and tongue popped out like one of those funny little*
24 *rubber dolls that you squeeze just for a laugh. But*
25 *unlike those silly dolls, this wasn't funny, no, this*
26 *wasn't funny at all. He was rude, he tried to rape*
27 *me. And rape is not funny. He's just lucky he didn't*
28 *live or I would have reported him. I would have told*
29 *the manager about their unhelpful help. I walked*
30 *over him, got my coat, put it back on, buttoned my*
31 *ruined blue blouse, finished my shopping and left. I*
32 *drove home in a huff, turned on the T.V. and*
33 *watched for a while until I finally calmed down. But*
34 *there's nothing on the news these days but crime and*
35 *violence. What a sad world we live in. Murder, rape,*
36 *endless crimes. Dangerous, it's dangerous out there.*

1 *Soon I fell asleep in front of the T.V.*

2 I awoke when Jerry, my husband, came

3 home. He kissed me hello, saw me still in my

4 bathrobe, asked me if I went out today. "Of

5 course," I said, "I go out every day, silly, you

6 know that." He looks at me so sad sometimes. I

7 think he worries about me too much. I watched

8 him put away the groceries that he brought

9 home. "You have to go out!" he said. "You can't

10 stay in forever."

11 "Jerry, Jerry, I do. Every day, every day I go

12 out." But I really don't think Jerry believes me.

13 So I've stopped telling him about all those hor-

14 rible things I see out on the streets every day. I

15 don't want to bother him, concern him. But

16 someone has to know, right? People must be

17 told, be warned. That's why I told you. And now

18 you know. Yes, someone has to hear. It's a very

19 scary place; a very scary world out there. Dan-

20 gerous. ...Dangerous.

21

22

23

24

25

26

27

28

29

30

31

32

33

34

35

36

Helen

Helen has a very difficult upsetting phone call with her sick mother.

1 No Ma, kids are fine. Yeah, everything's....
2 Fine, really, yes. ...Seven and three. Yeah, Ron-
3 nie's... and Steven's three, right. Three. Yeah,
4 three years.... Yeah, time does....
5 *(As if to a child)*
6 What? Uh-huh, that's right.... Tomorrow.
7 Tomorrow, right, uh, huh. *(Smiling)* Tomorrow's
8 Monday Ma, all day. I don't know, sometime in
9 the afternoon. Late afternoon. I'm going.... Ma,
10 I'll come, I'm coming.... Late afternoon. No, the
11 kids are fine. What? Ronnie's seven and
12 Steven's.... *(Becoming concerned)* Ma, I can't... Not
13 now. I can't come in now, no. It's late. It's snow-
14 ing out. Look outside. Well, get up and move the
15 curtain. You'll see, there's a terrible storm.
16 *(Impatiently)* Well, you have to get out of bed to...!
17 I can't come in Ma, it's late. It's nearly ten o'....
18 Just look out the window. You have to get out
19 of bed to.... *(Softer)* There's nothing to be
20 afraid.... Ma, I can't come in. There's a storm,
21 it's... Well, turn the lights on. Why are you sit-
22 ting in the dark? Get out of the bed and.... Turn
23 the lights on, Mom! Who tied...? Nobody tied you
24 to the bed, Ma. No, they wouldn't do that.
25 *(Starting to pace, becoming agitated)* Ma... Ma,
26 breathe! Breathe, Ma. Just take a breath!
27 Breathe! Alright, call the nurse! Push...! Ma,
28 breathe! No, you're not gonna die, Ma! Just

1 breathe! You're not gonna die! Take a breath! No
2 daddy's.... Daddy's not downstairs, no. He's not
3 here anymore. Daddy's.... Breathe, Ma! Call the
4 nurse! The switch by the bed, see? It's a white
5 switch. See it? Daddy's not here anymore, Ma.
6 He can't.... *(Trying to be calm)* Ma, listen to me.
7 Ma, all you have to do.... Just take one breath.
8 One breath, Ma! Breathe! Breathe, Ma! One....
9 One...! Ma, breathe! ...that's right. *(A beat, more*
10 *relaxed)* That's.... 'Atta.... 'Atta girl. That's my....
11 See? Now take another. Uh-huh. ...Another. See?
12 See how good that feels. See? No, you're not
13 gonna.... See? Everthing's fine, yeah. *(Softly,*
14 *relieved)* Told you there was nothing to.... Alright,
15 OK, you go to sleep. Yeah, the white switch,
16 right. The nurse'll be right in. Are you pushing
17 it?... Good, good girl. You'll see, she'll be right....
18 I love you, too. ...Ronnie's seven, yeah. Just
19 turned seven. ...April. And Steven's.... That's
20 right, tomorrow. ...Of course I know where
21 your.... Of course I.... *(A beat, softly)* Ma, do you
22 know who this is? ...No, Sydelle's your sister.
23 This isn't.... It's Helen, Ma. Helen, your daugh-
24 ter. Yeah, with the brown... the brown hair,
25 right. I miss you too, uh-huh. Alright, go to bed
26 now.... She'll be right in and give you some
27 water. I'll see you tomorrow... In the afternoon.
28 I don't know, after three. Good night. Good....
29 Yeah, Helen, with the brown.... ...And the two lit-
30 tle boys, right. Good night, Ma. Good.... I love
31 you too. Good night.
32 *(She hangs up the phone, stares straight ahead.)*
33
34
35
36

About the Author

Glenn Alterman is the author of *Street Talk (Original Character Monologs for Actors), Uptown, Two Minutes and Under, The Job Book — 100 Acting Jobs For Actors, The Job Book II — 100 Day Jobs For Actors,* and *What To Give Your Agent For Christmas (And 100 Other Helpful Hints For Working Actors).*

Street Talk and *Uptown* were the number one best selling books of original monologs in 1992 and 1993, and along with *The Job Book — 100 Acting Jobs for Actors* and *The Job Book II (100 Day Jobs For Actors)* were featured selections in the Doubleday Book Club (Fireside Theater). *Two Minutes and Under* recently went into its second printing. His plays *Like Family* and *The Pecking Order* were optioned by Red Eye Pictures (with Alterman writing the screenplay). *Nobody's Flood* won the Bloomington National Playwriting Competition (finalist in the Key West Theater Festival), *Coulda-Woulda-Shoulda* won the Three Genres Playwriting Competition (including publication in the Prentice Hall college textbook). He wrote the book for *Heartstrings — The National Tour* (commissioned by the Design Industries Foundation for AIDS), a thirty-five city tour which starred Michelle Pfeiffer, Ron Silver, Christopher Reeve, Susan Sarandon, Marlo Thomas and Sandy Duncan. Other plays include *Kiss Me When It's Over* (commissioned by E. Weissman Productions), starred in and directed by Andre DeShields; *Tourists of the Mindfield* (semi-finalist in the L. Arnold Weissberger Playwriting Competition at New Dramatists); and *Street Talk/Uptown* (based on his books), produced at the West Coast Ensemble in Los Angeles. *Goin' Round on Rock*

Solid Ground and *Unfamiliar Faces* were finalists at the Actors Theater of Louisville. *Spilt Milk*, received its premier at Beverly Hills Rep (Theater 40) and was selected to participate in the Samuel French One-Act Play Festival. *The Danger of Strangers* won Honorable Mention in both the Deep South Writers Conference Competition and the Pittsburgh New Works Festival, and was also a finalist in the George R. Kernodle Contest (with productions at Circle Rep Lab and The West Bank Cafe Downstairs Theater Bar). His plays have been performed at Primary Stages, Circle in the Square (Downtown), HOME (Tiny Mythic Theater), The Duplex in the Turnip Festival, Playwrights Horizons, La Mama, on Theater Row (in New York), and at many other theaters around the country. He is a member of the Dramatists Guild, the Authors Guild, National Writers Union, Cherry Lane Performing Artists, Circle Rep Lab and The Lab.

His new book, *Promoting Your Acting Work*, will be published later this year (Allworth Press).

Order Form

Meriwether Publishing Ltd.
P.O. Box 7710
Colorado Springs, CO 80933
Phone: 800-937-5297 Fax: 719-594-9916
Website: www.meriwether.com

Please send me the following books:

_____ **Two-Minute Monologs #BK-B219** $15.95
by Glenn Alterman
Original audition scenes for professional actors

_____ **Audition Monologs for Student** $15.95
Actors #BK-B232
edited by Roger Ellis
Selections from contemporary plays

_____ **Audition Monologs for Student** $15.95
Actors II #BK-B249
edited by Roger Ellis
Selections from contemporary plays

_____ **Fifty Professional Scenes for Student** $15.95
Actors #BK-B211
by Garry Michael Kluger
A collection of short two-person scenes

_____ **Truth in Comedy #BK-B164** $17.95
by Charna Halpern, Del Close and Kim "Howard" Johnson
The manual of improvisation

_____ **Art by Committee #BK-B284** $22.95
by Charna Halpern
A guide to advanced improvisation (book & DVD)

_____ **Young Women's Monologs from** $15.95
Contemporary Plays #BK-B272
edited by Gerald Lee Ratliff
Professional auditions for aspiring actresses

These and other fine Meriwether Publishing books are available at your local bookstore or direct from the publisher. Use the handy order form on this page. Check our website or call for current prices.

Name: _____ e-mail: _____

Organization name: _____

Address: _____

City: _____ State: _____

Zip: _____ Phone: _____

❑ **Check Enclosed**
❑ **Visa / MasterCard / Discover #** _____

*Expiration
date:* _____
Signature: _____
(required for Visa/MasterCard orders)

Colorado residents: Please add 3% sales tax.
Shipping: Include $3.95 for the first book and 75¢ for each additional book ordered.

❑ *Please send me a copy of your complete catalog of books and plays.*